Paul Sample

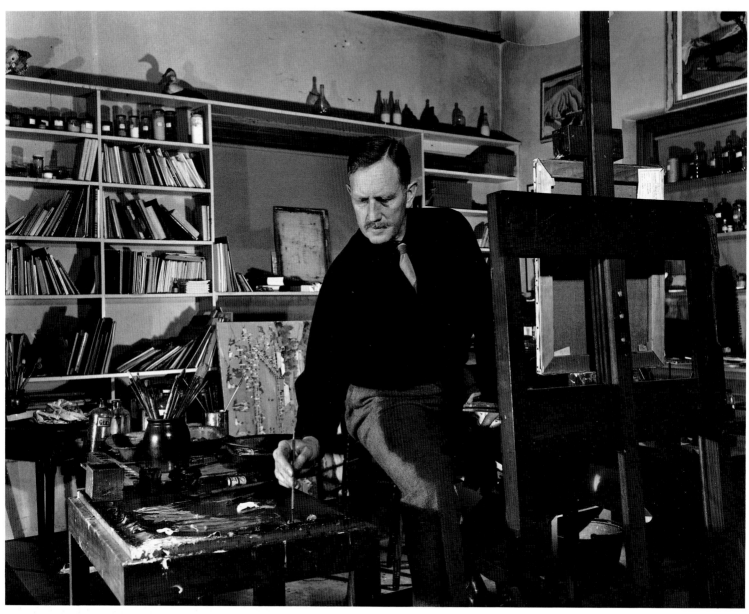

Paul Sample in his studio in Carpenter Hall, Dartmouth College, in 1949

Paul Sample

Painter of the American Scene

With an essay by Robert L. McGrath
and an extended chronology by Paula F. Glick

Hood Museum of Art, Dartmouth College
June 4–August 28, 1988

Distributed by University Press of New England
Hanover and London

LIBRARY OF CONGRESS CATALOGING-IN-PUBLICATION DATA

Sample, Paul, 1896–1974.
 Paul Sample, painter of the American scene: Hood Museum of Art, Dartmouth College, June 4–August 28, 1988 / with an essay by Robert L. McGrath and extended chronology by Paula F. Glick.
 p. cm.
 Catalog of an exhibition.
 Includes index.
 1. Sample, Paul, 1896–1974—Exhibitions. 2. Painting, American—Exhibitions. 3. Painting, Modern—20th century—United States—Exhibitions. 4. Regionalism in art—United States—Exhibitions.
I. McGrath, Robert L., 1935– . II. Glick, Paula F. III. Hood Museum of Art. IV. Title.
N D 237. S 264 A 4 1988
759.13—dc 19 87-28943
I S B N 0-944722-00-8 (cloth) C I P
I S B N 0-944722-01-6 (paper)

Design: Joyce Kachergis
Typography: G&S Typesetters

Cover/jacket illustration: *Beaver Meadow,* 1939. Oil on canvas, 40 × 48¼ inches. Hood Museum of Art, Dartmouth College, Gift of the Artist (cat. no. 32).

Printed and bound in Japan

This project is supported by a grant from the National Endowment for the Arts.

Contents

Lenders to the Exhibition

Abbott Laboratories Collection

Addison Gallery of American Art, Phillips Academy, Andover, Massachusetts

The Brooklyn Museum, Brooklyn, New York

Mr. and Mrs. Robert P. Burroughs

Clement Caditz

Mr. and Mrs. Joseph S. Caldwell, III, Dartmouth College Class of 1951

Canajoharie Library and Art Gallery, Canajoharie, New York

Capricorn Galleries, Bethesda, Maryland

Brian David Carmel

The Currier Gallery of Art, Manchester, New Hampshire

William A. Farnsworth Library and Art Museum, Rockland, Maine

Fisher Gallery, University of Southern California, Los Angeles

Audrey Chamberlain Foote, Washington, D.C.

Paula and Irving Glick

Mr. and Mrs. Robert Goshorn

Joslyn Art Museum, Omaha, Nebraska

Lowe Art Museum, University of Miami

The Metropolitan Museum of Art

Museum of Fine Arts, Boston

Museum of Fine Arts, Springfield, Massachusetts

National Academy of Design, New York

New Britain Museum of American Art

Susan Poling Norberg, Leesburg, Florida

Town of Norwich, Vermont

Private Collections

Springville Museum of Art, Springville, Utah

Swarthmore College

University Art Museum, University of Minnesota, Minneapolis

U.S. Army Center of Military History

D. Wigmore Fine Art, Inc., New York

Williams College Museum of Art, Williamstown, Massachusetts

T. W. Wood Art Gallery, Montpelier, Vermont

When Paul Sample graduated from Dartmouth College in 1921, he was known primarily as a heavyweight boxing champion and a jazz saxophone player. He took up painting soon after graduation while recovering from tuberculosis. No one, least of all Sample himself, would have predicted his rise to national prominence as a painter and his eventual return to Dartmouth as artist-in-residence. As Sample's professional reputation flourished, Dartmouth gave increasing recognition to his achievement. In 1935 and again in 1941, the College sponsored one-man exhibitions of Sample's work. In 1936 he was awarded an honorary Master of Arts degree. Two years later he was invited to serve as artist-in-residence, a position he retained until 1962. The College awarded him a Doctorate of Humane Letters on his retirement, and the following year assembled an exhibition of twenty-six of his paintings. In 1975, a year after Sample's death, Dartmouth's Baker Library mounted a memorial exhibition of sketches selected from the large collection of works he had donated to the college. Since then the only sizable exhibition of Sample's work was assembled in 1984 by the Lowe Art Museum of the University of Miami; that show chiefly addressed his paintings in the Regionalist style. A truly comprehensive reappraisal of Sample's career is long overdue, and it seems appropriate for Dartmouth's own museum to undertake it.

This exhibition appears at a time when art historians and the general public are looking at American art from the 1930s and 1940s with renewed appreciation. The current interest in Regionalism and American Scene painting coincides with the emergence of "postmodern" variations on the realist tradition, as well as with a widespread desire to reevaluate the American experience during the Depression era. Paul Sample was one of the most highly regarded artists associated with that period. By the 1960s, however, his figurative and realist art had been eclipsed by the triumph of abstract expressionism, a triumph that was validated by the modernists' unilinear version of art history. Now that Sample's achievement is being rediscovered, the importance of his contribution to American painting is evident. Professor Robert McGrath's essay on that achievement, which clarifies its significance in the context of trends in the 1930s, plays a crucial role in this exhibition. We are extremely grateful to him for his perceptive analysis, as well as for his invaluable contributions as guest curator.

In assembling this exhibition, the Hood Museum has benefited from the expertise and generosity of many people. In addition to guest curator Robert L. McGrath, Professor of Art History at Dartmouth College, I would like to pay special tribute to Paula F. Glick, the artist's chief biographer, who has selflessly shared her knowledge of Sample's career and the location of his existing works. Her contribution extends far beyond her prepa-

ration of the in-depth chronology of the artist's career published here. The organization and direction of this exhibition were carried out by Barbara MacAdam, our curator for American art. Without Ms. MacAdam's diligence and skillful guidance, this exhibition and catalogue would not have been achieved. Paul Sample's widow, Sylvia Sample-Drury, provided invaluable support and assistance, particularly in making available for study her late husband's diaries. We are deeply grateful to her.

The myriad details that surround a loan exhibition and publication of this scope were ably handled by Heidi Lansburgh, Research Associate for the project. Mark Segal, Dartmouth Class of 1987, assisted with research during the exhibition's early stages. Members of the museum's registrar staff—Rebecca Buck, Gregory Schwarz, and Patti Houghton—arranged for the photography, insurance, and transportation of the numerous loans. The Museum's curators for exhibition, Evelyn Marcus and Robert Raiselis, are responsible for the design and installation of the show. We also wish to thank the Museum's assistant director Timothy Rub and administrative assistant Hilary Ragle for valuable contributions to the project.

Others who assisted in a number of ways are Brian Dursam, Registrar for the Lowe Art Museum, University of Miami; John L. Giegerich, Dartmouth Class of 1951; Martha J. Hoppin, Curator of American Art at the Museum of Fine Arts, Springfield, Massachusetts; Amit Malhotra, Dartmouth Class of 1990; Michael T. Merrow, Dartmouth Class of 1985; Deedee Wigmore, President of D. Wigmore Fine Art, Inc.; and the staffs of Dartmouth's Special Collections and Sherman Art Library.

Holly Glick, director of external relations for the Hood Museum of Art, helped to locate the resources needed for this endeavor. Among those who have supported this project financially, we would like to make specific mention of the Harrington Gallery Fund; the Philip Fowler 1927 Memorial Fund; the Leon C. 1927, Charles L. 1955, and Andrew J. 1984 Greenebaum Fund;

the Marie-Louise and Samuel R. Rosenthal Fund; and the Bernard R. Siskind 1955 Fund. The National Endowment for the Arts provided a generous grant in its "utilization of collections" category, which helps museums research, exhibit, and publish works in their own collections. Roughly one-third of the works by Paul Sample in the present show are from the Dartmouth collection.

Above all, we are indebted to our many lenders, who responded to our requests for loans with enthusiasm and generosity. We also owe thanks to the many individuals who, on learning of the exhibition, offered to make available works from their collections. Unfortunately, owing to the considerable size of Sample's output and the Museum's limited gallery space, many works of high quality could not be included in the exhibition. The opportunity to review these additional works, however, has informed the essays prepared by our guest authors, thereby enriching our collective understanding of Paul Sample's contribution to American art.

Jacquelynn Baas
Director

Paul Sample

Paul Sample, 1896-1974
An Extended Chronology

Paula F. Glick

The following abbreviations are used in this Chronology:

A.I.Ch.	The Art Institute of Chicago
BIAA	The Butler Institute of American Art, Youngstown, Ohio
BMFA	The Museum of Fine Arts, Boston
Carn.I.	The Carnegie Institute, Pittsburgh
CGA	The Corcoran Gallery of Art, Washington, D.C.
FUVM	Robert Hull Fleming Museum, University of Vermont, Burlington
MMA	The Metropolitan Museum of Art
NAD	The National Academy of Design, New York
PAFA	The Pennsylvania Academy of the Fine Arts, Philadelphia
VMFA	The Virginia Museum of Fine Arts, Richmond
WMAA	The Whitney Museum of American Art, New York

1896. Birth of Paul Starrett Sample, the first child of construction engineer Wilbur Stevenson Sample and his wife, Effie Averill Sample (née Madden), on September 14 in Louisville, Kentucky.

1898. Birth of second son, Donald, to Wilbur and Effie Sample, on October 20 in Indianapolis, where Wilbur Sample was working on a construction project.

1902–7. Because of the transient nature of the construction business, Wilbur Sample moved his family frequently. The family moved to Anaconda, Montana, in 1902 and later returned east to Richmond, Virginia. The

Samples lived in the Washington, D.C., area when Paul celebrated his eighth and ninth birthdays.

1907–11. The family lived for four years at various locations on the West Coast, including Portland, Oregon, and Berkeley, Carmel, and San Francisco, California. Perhaps as a result of this peripatetic existence, the two brothers were very close and developed similar interests.

1911. The family settled in Glencoe, Illinois.

1912–16. While attending New Trier High School in Glencoe, Sample pursued hobbies that became lifelong interests: fishing, bird watching, music, and drawing. At

this time he drew caricatures of imaginary subjects that he called "nutty mugs."

1916. Sample entered Dartmouth College as a member of the Class of 1920. He was on the football and basketball teams and pledged the Delta Kappa Epsilon (DKE) fraternity. To earn spending money he worked as a waiter at the Wheelock Club, a local eating club.[1]

1917. In February Sample was initiated into DKE. That same month he received a saxophone from his father. Although he could not read music, he learned to improvise and played jam sessions with friends. Inspired by these sessions, he quickly learned to read music and within a month was performing with an informal band called the freshman orchestra. The band later played at various college functions, including faculty dances. Following the entrance of the United States into World War I, Sample enlisted in the Naval Reserve, despite the fact that his father wanted him to remain in college. He drilled at Dartmouth in a program for college recruits.

1918–19. Sample served in the Merchant Marine on the *S.S. Republic,* earning a third mate's license. He loved the life aboard ship and considered a career at sea.

1919. At the insistence of his father Sample returned to Dartmouth after the war, joining his brother Donald (Din), also a student at the College. Paul was not a particularly good student, but he excelled in athletics and became an intercollegiate heavyweight boxing champion. Together with his brother he organized the Barbary Coast Band, a popular jazz group that played both college and commercial engagements.[2]

1920. Donald Sample became ill with tuberculosis in the fall and was sent to Saranac Lake, New York, for treatment.

1921. Paul Sample graduated from Dartmouth in June. While visiting his brother at Saranac Lake later that summer, he himself became gravely ill with tuberculosis.

He remained at Saranac Lake until 1925, when he was pronounced cured.

1923. At Saranac Lake Sample became more introverted and developed a passion for reading. His interests included history, the classics, philosophy, and religion. During their convalescence, Paul and his brother discussed their future careers. Disillusioned with business by the financial reverses experienced by their father, both decided to pursue a vocation in the humanities. Because Paul had a flair for drawing, his physician, a Dr. Kinghorn, suggested that the young man consider a career in the fine arts. The doctor arranged for Paul and Donald to take lessons in drawing and painting from the noted painter Jonas Lie, whose tubercular wife was also being treated at Saranac Lake.

1923–25. Paul and Donald Sample continued their treatment at Saranac Lake. Unlike his brother, who disregarded the doctor's orders, Paul was a model patient and carefully followed the prescribed regimen. While at Saranac Lake he fell in love with Sylvia Howland, a Vermont girl who was also being treated for tuberculosis. Although Paul wished to marry her, he did not propose because of the uncertainty of his finances. Nevertheless they kept company, and she accompanied him while he sketched and encouraged him in his chosen career.

1925. His tuberculosis pronounced cured, Paul Sample went to New York City in late March. Supported by funds from the Veterans' Bureau, he began a course in commercial art at the Greenleaf Art School on April 1. Meanwhile his brother's condition had deteriorated. In January his mother had taken Donald to Tucson, Arizona, and then to California, in an attempt to improve his health. In late May Paul and his father received word that Donald was dying, and both moved from the east to Monrovia, California, to be with him.

Donald died on June 17. The brothers had been constant companions for almost all of their lives, and for several months Paul was very depressed. In addition, the

family finances were nearly exhausted, and neither Paul nor his father had a job.

Supported again by the Veterans' Bureau, Paul resumed art studies at the Otis Art Institute in Los Angeles in late July. Although at 29 he was one of the oldest students in the class, he enjoyed the work thoroughly. He missed New England and the Adirondacks, but he enjoyed the California climate and settled near Los Angeles in Eagle Rock.

1926. Although pleased with his progress in painting, Sample left the Otis Art Institute in June to find a job. He found one with the Biltmore Art Galleries in Los Angeles, but was forced to leave because of ill health. On August 3 he wrote in his diary: "I am eventually going to be a painter and a damned good one. And what is more I am going to make money at it."[3]

In September he began to teach drawing in the School of Architecture at the University of Southern California. He taught part-time at first, but later was increased to full-time. By the mid-1930s he had become Chairman of the Art Department and was exhibiting his work in national exhibitions.

Awards: Special Award of Honor, Exhibition at Springville Museum of Art, Springville, Utah: *Moored Fishing Boats.*

Group Exhibitions: Three-man faculty exhibition (with F. Tolles Chamberlain and one other faculty member) at the University of Southern California.

1927. Sample and Sylvia Howland had corresponded since he left Saranac Lake. Now she was well and visited Paul in September while traveling with her parents in California. They decided to be married the following year.

Sample had frequent bouts of illness all through the year, but painted regularly with Chamberlain and Stanton MacDonald-Wright. He was also friendly with other young artists, including Barse Miller, Millard Sheets, and Phil Dike.

Solo Exhibition: Pasadena Art Institute. (His first one-man exhibition.)

1928. During the summer Sample showed his work to Stendahl Galleries in Los Angeles, but Mr. Stendahl rejected the work. On December 1 Paul and Sylvia were married.

1929. While still teaching at the University of Southern California, Sample also taught night classes for the Chouinard School of Art in Los Angeles.

Awards: First Prize, Santa Monica Art Association Exhibition: *Boats.*

1930. During the summer Paul and Sylvia traveled east to visit her parents. Although Sylvia remained with her family until October, Paul returned in September to his post at the University of Southern California, where he taught drawing, watercolor, and for the first time a life class. Despite his full teaching load, he continued to paint on his own.

Awards: The Keith-Spaulding Prize, California Art Club / First Prize, Exhibition at the Los Angeles Museum of Art / Honorable Mention for Landscape, 43rd Annual Exhibition of American Paintings and Sculpture, A.I.Ch.[4]

Group Exhibitions: 12th Exhibition of Contemporary American Oil Paintings, CGA: *The Country Circus* (cat. no. 5) / The Albright-Knox Art Gallery (Buffalo): *The Country Circus* / 105th Annual Exhibition, NAD: *Inner Harbor.*

1931. The Samples again traveled east to visit Sylvia's family. Whenever he visited the East Coast, Sample showed his work to art dealers in New York City. In November Macbeth Gallery began to exhibit his work.

Awards: Second Hallgarten Prize, 106th Annual Exhibition, NAD: *Dairy Rounds.*

Group Exhibitions: 126th Annual Exhibition, PAFA: *Fish Harbor* (cat. no. 3) / 44th Annual Exhibition of American Paintings and Sculpture, A.I.Ch.: *Fish Harbor.*

1932. Sample received great satisfaction when Stendahl Galleries, which had rejected his work four years earlier, agreed to exhibit his paintings. Stendahl exhibited many prestigious artists, including the Mexican painter David Alfaro Siqueiros, who had a one-man exhibition there that May.

As president of the California Art Club, Sample invited Siqueiros to conduct a class in fresco painting for professional artists at the Chouinard Art School. Sample attended the classes in the company of Millard Sheets, Barse Miller, Henri de Kruif, and others.

From mid-June through early July, Sample and nine other artists worked with Siqueiros on a mural for a wall of the Chouinard Art School sculpture court. These artists, designated by Siqueiros as the "Block of Mural Painters," were assigned to paint in the upper two-thirds of the fresco; the bottom of the mural was to be painted by Siqueiros, who did not execute his portion until the others had left. The additions by Siqueiros transformed the mural into a revolutionary workers' meeting.[5]

On Thursday, July 7, the mural was unveiled.[6] During a lecture prepared for the occasion, Siqueiros mentioned Sample several times and called him a good "co-operator." Sample was not present at the unveiling, and did not know about the subject of the mural or the lecture until he heard his name mentioned on the radio the following day. On July 9 Sample wrote to his wife, "it is thought that we have all gone 'red'—under Siqueiros [*sic*] influence, and De Kruif is quite worried and wants to publish a statement to the contrary. I don't care one way or the other."

While working with Siqueiros, Sample also taught summer school—life classes and landscape—at the University of Southern California. In addition Sample painted in the evenings at least once a week at Chamberlain's studio. When summer school ended Sample went east to join his wife, who had traveled to New England to visit her family.

Awards: Isador Gold Medal, 107th Annual Exhibition, NAD: *Unemployment* (cat. no. 9) / First Prize Marine Painting, Pasadena Art Institute.

Group Exhibitions: Two-man exhibition (with Phil Dike), Stendahl Galleries, Los Angeles / Four-man exhibition (with Gerald Foster, C. G. Nelson, and A. Henry Nordhausen), Macbeth Gallery, New York / 45th Annual Exhibition of American Paintings and Sculpture, A.I.Ch.: *Dairy Rounds* / 127th Annual Exhibition of Painting and Sculpture, PAFA: *N. Broadway Neighborhood; The River.*

1933. Sample continued teaching at the University of Southern California. Late in the year he left Macbeth Gallery to affiliate with Ferargil Galleries in New York City. It was Fred Price of Ferargil Galleries who earlier in the year had brought Sample's work to the attention of the Museum of Fine Arts in Springfield, Massachusetts, which purchased the painting *Church Supper* (cat. no. 13).

Group Exhibitions: 13th Annual Exhibition of Contemporary American Oil Paintings, CGA: *Speech Near Brewery* (cat. no. 11) / 128th Annual Exhibition, PAFA: *Sunday Morning* / *American Painting of Today*, Worcester Art Museum: *Church Supper.*

1934. Sample accepted the first of many assignments from *Fortune* magazine.

Awards: First Prize, Laguna Beach Museum of Art, First Art Association: *Unemployment* (cat. no. 9).
Commissions: Fortune magazine—Painting of San Pedro Harbor, Los Angeles (appeared in October issue).
Solo Exhibitions: Ferargil Galleries, New York.
Group Exhibitions: 129th Annual Exhibition, PAFA: *Celebration* (cat. no. 16) / Carnegie Foundation World Tour: *Barber Shop* / *A Century of Progress Exhibition of Painting and Sculpture*, A.I.Ch.: *Celebration* (cat. no. 16).

1935. Sample was among the artists invited by the Section of Painting and Sculpture of the Treasury Department to submit designs for a mural decoration for the new headquarters of the Post Office Department in Washington.[7] He submitted designs illustrating the effect of the mail on the development of the West (see *Gold Rush Town,* cat. no. 23). The designs for the project were rejected, but Edward Bruce, Chief of the Section of Painting and Sculpture, asked Sample to paint murals for other Treasury Department projects.

Commissions: Fortune magazine—painting of *Norris Dam* (cat. no. 26; appeared in May issue)[8] / *Fortune* magazine—paintings of Anaconda Copper Company installations in Butte, Montana (appeared in December 1936 and January 1937 issues) / Section of Painting and Sculpture of the United States Treasury Department—mural for the post office of Redondo Beach, California.
Solo Exhibitions: Carpenter Art Galleries, Dartmouth College.
Group Exhibitions: 14th Biennial Exhibition of Contemporary American Painting, CGA: *Between Shows* / 110th Annual Exhibition, NAD: *Celebration* (cat. no. 16) / 14th International Watercolor Exhibition, A.I.Ch.: *Northern Village; Purple Barn; Yellow Mansion.*

1936. In January Sample was hospitalized with a respiratory problem, but by early spring he was busy teaching and preparing designs for the Redondo Beach mural.

Sample and his wife spent the summer with her family in Vermont. While there he developed appendicitis and later peritonitis. Following three operations, he remained in Vermont, recuperating until mid-November.

Honors: Honorary Master of Arts Degree, conferred by Dartmouth College in June.
Awards: Temple Gold Medal, 131st Annual Exhibition, PAFA: *Miners Resting* / Honorable Mention, The International Exhibition of Paintings, Carn.I.: *Barber Shop.*
Group Exhibitions: Second Biennial Exhibition of Contemporary American Sculpture, Watercolors, and Prints, WMAA: *Boxers Working* / 47th Annual Exhibition of American Paintings and Sculpture, A.I.Ch.: *Band Concert* / 15th International Watercolor Exhibition, A.I.Ch.: *Santa Fe Station* (cat. no. 54) / 111th Annual Exhibition, NAD: *Miners Resting.*

1937. Granted a sabbatical leave from the University of Southern California for the academic year 1937–38, Sample toured the nation's ports for several months working on a commission from *Fortune* magazine. By August he had completed his mural for the Redondo Beach Post Office. Sample and his work were featured in an article in the November 15 issue of *Life* magazine.

Honors: Elected to associate membership in the National Academy of Design.
Commissions: Fortune magazine—paintings of United States ports (see *Stockton Harbor,* cat. no. 27).
Solo Exhibitions: Ferargil Galleries, New York / Courvoisier Galleries, San Francisco.
Group Exhibitions: 112th Annual Exhibition, NAD: *Janitor's Holiday* (cat. no. 29)[9] / 132nd Annual Exhibition, PAFA: *Norris Dam* (cat. no. 26) / 1937 International Exhibition of Paintings, Carn.I.: *Ward Room* (cat. no. 17).

1938. From January to June Sample and his wife toured Europe extensively, visiting England, Belgium, France, and Italy. He sketched or painted watercolors at every opportunity.

Sample was the subject of an article by Alfred Frankenstein in the July issue of the *Magazine of Art.*

He was appointed artist-in-residence at Dartmouth College beginning in September. He was given a studio in the College's art building, Carpenter Hall, and he and his wife resided in an apartment in Hanover. He began exhibiting his work at the Grace Horne Galleries in Boston.

Group Exhibitions: First Biennial Exhibition of Contemporary American Paintings, VMFA: *Impasse* / 1938 International Exhibition of Paintings, Carn.I.: *Spring Song* / 133rd Annual Exhibition of Painting and Sculpture, PAFA: *Storm over Willoughby Lake* / 113th Annual Exhibition, NAD: *Lamentations V : 18 (Fox Hunt),* cat. no. 33.[10]

1939. Although he was not required to teach or lecture, Sample offered life classes for Dartmouth students and the college community. He concentrated on watercolors for much of the year. During the summer the Samples went up to Lake Willoughby, Vermont, where Sylvia's family owned several cottages. This became a regular summer activity. Late in the year the Samples became the parents of a son, Tim.

Honors: Served as juror for the National Midyear Show of BIAA.[11]
Commissions: Fortune magazine—scenes of Vermont (appeared in the February issue) / Section of Painting and Sculpture of the United States Treasury Department—mural for the post office of Westerly, Rhode Island. The mural was never executed.[12]
Group Exhibitions: American Art Today, Exhibition at the New York City World's Fair: *Spring Song* / Golden Gate International Exposition, Palace of Fine Arts, San Francisco: *Going to Town* (cat. no. 28) / 1939 International Exhibition of Paintings, Carn.I.: *Lamentations V : 18 (Fox Hunt),* cat. no. 33 / Philadelphia Watercolor Show, PAFA: *White River Junction; Central Vermont; Hunter and Freight Train* / 10th Biennial International Watercolor Exhibition, Brooklyn Museum: *Between Classes* / Exhibition of Painting and Sculpture Designed for Federal Buildings, CGA / *Ten American Watercolor Painters,* BMFA: *Santa Fe Station* (cat. no. 54); *The Junction* (cat. no. 62); seven others[13] / 18th International Watercolor Exhibition, A.I.Ch.: *Horse Power; Central Vermont* / *The New England Artist Interprets the New England Scene: A Contemporary Watercolor Exhibition,* Addison Gallery of American Art, Andover, Massachusetts: *The River Freezes; The Return of the Hunter; Grey Day, White River Junction.*

1940. Sample was active in Dartmouth affairs. He executed the scenic backdrop for a Dartmouth Community Chorus production of *H.M.S. Pinafore.* He also gave lectures on painting to alumni. Later in the year he painted a mural for the house of his old fraternity, Delta

Kappa Epsilon. During the summer he taught a brief course in painting at the University of Vermont.

Honors: Served on the jury of awards of the Second Biennial Exhibition of Contemporary American Paintings at VMFA and on the selection jury of the 1940 New Year Show, BIAA.

Awards: Prize for Excellence, *Contemporary Art of the United States*, International Business Machines (IBM) Corporation exhibition, New York World's Fair. (*Going to Town*, cat. no. 28, was voted one of the three most popular paintings at the exhibition.)

Commissions: Life magazine—sketches at the political conventions (unpublished).

Group Exhibitions: 135th Annual Exhibition, PAFA: *Spring Song /* 19th International Watercolor Exhibition, A.I.Ch.[14] / Annual Exhibition of Contemporary American Painting, WMAA: *Noon at the Fair /* Second Biennial Exhibition of Contemporary American Paintings, VMFA: *Ward Room* (cat. no. 17) / 115th Annual Exhibition, NAD: *Matthew VI : 19 (The Auction)*, cat. no. 34[15] / *Mural Designs for Federal Buildings,* The National Gallery of Canada / Golden Gate International Exposition, Palace of Fine Arts, San Francisco: *Beaver Meadow* (cat. no. 32).

1941. Paul Sample was recognized as a major American painter. His works were illustrated in *Art News*.[16] He received accolades from the art world, and his talent was in demand by both private organizations and public institutions. He left Ferargil Galleries, affiliating with the Associated American Artists (AAA) Gallery in New York City and the Vose Galleries in Boston. Late in the year the Samples moved to their new house on Hobson Road in Norwich, Vermont.

Honors: Elected to full membership in the National Academy of Design / Served on the juries of the 136th Annual Exhibition of PAFA, and of art competitions in Pittsburgh; Springfield, Massachusetts; Syracuse, New York; and Burlington, Vermont.

Awards: Prize for Excellence in Watercolor, The Lotos Club, New York.

Commissions: Treasury Department—for a mural for the post office of Apponaug, Rhode Island / *Life* magazine—a painting portraying the manufacture of munitions in Detroit, *Shell Factory*, cat. no. 39 (appeared in the July 7, 1941, issue) / American Tobacco Company— paintings of tobacco industry (see cat. no. 40).[17]

Solo Exhibitions: Carpenter Art Galleries, Dartmouth College / FUVM / Vose Galleries, Boston / Ferargil Galleries, New York.

Group Exhibitions: 136th Annual Exhibition, PAFA: *Rehearsal (Nora Kaye Rehearsing)*, cat. no. 37 / 17th Biennial Exhibition of Contemporary American Oil Paintings, CGA: *Lamentations V : 18* (cat. no. 33) / *Contemporary Painting in the United States*, MMA: *Berlin Four Corners; Whitcomb Mills* / Annual Exhibition of Contemporary American

Sculpture, Watercolors, Drawings, and Prints, WMAA / *America Yesterday and Today,* Montclair Art Museum, Montclair, N.J.: *Beaver Meadow* (cat. no. 32) / 35th Annual Exhibition of American Painting, Saint Louis Art Museum: *Matthew VI : 19* (cat. no. 34) / 115th Annual Exhibition, NAD: *Matthew VI : 19.*

1942. Feature articles on Sample appeared in three national magazines: *Esquire* (January), *Country Gentleman* (March), and *American Artist* (April). At home and at Dartmouth the artist worked on portraits and sketches for College activities. In his diary entry for January 15 Sample contrasts his opinions about painting with those of the Art Department at Dartmouth:

In the first place they are not primarily interested in painting—& I am. I feel that pictures have a justification simply in themselves—& indeed the origins of painting was [*sic*] due primarily to the impulse to communicate emotions by pictures & nothing more! They [the Art Department] insist painting was & should be a part of some utilitarian enterprise.

Sample completed his design for the Apponaug Post Office mural early in the year and sent it to Washington, where it was approved. But the project was delayed (in part because the mayor of Apponaug would have preferred a clipper ship), and Sample did not complete the mural until December 1942.

In February Sample began his first artist-correspondent assignment for *Life* magazine with the Department of Naval Aviation. That month he produced sketches and watercolors of the naval air station at Norfolk, Virginia. He returned to Norfolk in August and spent about a month sketching aboard the aircraft carrier *U.S.S. Ranger,* which was in the north Atlantic on a training mission.

Despite his professional commitments Sample found time for one of his favorite activities, listening to and playing music. He tried to spend some time each day with his flute, an instrument that he had only recently learned to play, and even took it with him when he traveled on business.

Honors: Served on the jury for the Artists for Victory exhibition at MMA.

Awards: Worcester Art Museum: *Barber Shop.*

Commissions: *Life* magazine—series of paintings on naval aviation / AAA Gallery—two war paintings for posters / American Tobacco Company—tobacco industry paintings / Office of Public Information—series of paintings depicting the transport of war materials.
Solo Exhibitions: CGA.
Group Exhibitions: 117th Annual Exhibition, NAD: *Winter Visitor.*[18]

1943. In early January Sample installed the completed mural at the Apponaug Post Office. In February he lectured at Colby College in Maine. This was the first of many college and art club lectures that he gave in his lifetime.

From March 8 to July 7 Sample worked on an artist-correspondent assignment for *Life* magazine in the Pacific Theater. He was sent to Pearl Harbor to do sketches of activities at the base. On April 21 his credentials were upgraded to permit him to accompany task forces anywhere in the Pacific. Thus he was able to spend two weeks aboard a submarine, the *S.S. Trigger,* on patrol below the surface between Pearl Harbor and Midway Island. His sketches of military activities in the Central Pacific appeared in the December 27, 1943, and June 26, 1944, issues of *Life.*

Honors: Served on the jury for the 118th Annual Exhibition, NAD.
Commissions: Life magazine—artist-correspondent in the Central Pacific.
Group Exhibitions: Painting in the United States, Carn.I: *Noon at the Fair.*

1944. While in Hanover, Sample offered both a life drawing class and a painting class at Dartmouth. Although the classes did not provide academic credits for Dartmouth students, there were always willing students.

On September 24 Sample left Hanover to join the Pacific Fleet again as an artist-correspondent for *Life* magazine. He was aboard the *U.S.S. Portland* during the invasion of the island of Leyte in the Philippines. When the attack began on October 20, Sample left the ship and went in with the troops. He spent time in the front lines both at sea and on land, and was often under fire. Nonetheless he sketched whenever he had the slightest opportunity.

One of his most powerful paintings, *Field Hospital in a Church (Delirium Is Our Best Deceiver),* cat. no. 45, was drawn from his experiences in a field hospital in the Philippines after injuring his ankle. Two entries in his diary are particularly relevant to the painting:

The hospital is in an old Spanish cathedral—very beautiful and cots are in rows entirely filling the spacious interior—some 200 feet in length. . . . I was wakened in the morning at 6:30 to find early mass going on. The Filipino worshippers were kneeling all around our cots. A small organ was playing. It was just getting light and the scene was one of the most moving of my life. The wounded watched sleepily—and the men who were catholics and who were able to get up joined the worshippers.

November 11, 1944.

2 G.I.s came in. One was obviously a mental casualty. He told me the war had ended that morning and that already his wife and mother had arrived to be with him. [He said] He had just left them down in the church. Also other wives and mothers were arriving every ½ hour—that he was sure mine would be waiting for me down in the church.

As he talked his chin was quivering and tears were streaming down his face.

November 15, 1944.

Sample did not return to the United States until almost Christmas, which he spent in California with his wife and son.

Commissions: Life magazine—artist-correspondent at the invasion of Leyte in the Philippines (appeared in the October 8, 1945, issue).
Group Exhibitions: 139th Annual Exhibition, PAFA.

1945. Sample resumed his painting and drawing classes at Dartmouth. In his journal he noted: "I had several Navy boys who were perhaps the best pupils I've had here. This summer they went to another duty."

Group Exhibitions: Painting in the United States, 1945, Carn. I.: *Field Hospital in a Church* (cat. no. 45).

1946. Increased enrollment forced Sample to schedule more classes at Dartmouth. More students were attending Dartmouth under the G.I. Bill, and returning veterans knew Sample's work from the *Life* articles. During the summer the family traveled to Lake Willoughby; the trips had been curtailed during the war years because of gasoline rationing.

Honors: Served on a jury at the New Britain Museum of American Art, New Britain, Connecticut.
Commissions: Chesapeake and Ohio Railway—two paintings.
Solo Exhibitions: Vose Galleries, Boston.
Group Exhibitions: Painting in the United States, 1946, Carn. I.: *The Return* (cat. no. 46).

1947.
Honors: Served on the jury of *Painting in the United States, 1947,* Carn. I.
Awards: Special Award, 122nd Annual Exhibition, NAD: *Field Hospital in a Church* (cat. no. 45) / Purchase Prize, Pepsi-Cola Competition: *Sharon's Sleigh Ride* (cat. no. 41).
Commissions: Gimbels Department Stores—Pennsylvania scenes.[19]
Group Exhibitions: 142nd Annual Exhibition, PAFA: *Change in the Weather / Painting in the United States, 1947,* Carn. I.: *Vermont Watering Place.*[20]

1948.
Solo Exhibitions: The Currier Gallery of Art, Manchester, N.H.
Group Exhibitions: Painting in the United States, 1948, Carn.I.: *Nearing Home.*

1949. Sample traveled a lot this year. In addition to his trips to Willoughby Lake and regular fishing trips to Quebec with his father-in-law, Fred Howland, he traveled nationwide, serving on juries for art exhibitions and sketching for commissions.

Honors: Served as chairman of the jury for the 21st Biennial Exhibition of American Painting, CGA / Served on jury of selection for forthcoming exhibition at MMA, *American Painting Today.*
Commissions: Paintings for *Cosmopolitan* magazine and *Readers' Digest.*
Solo Exhibitions: AAA Gallery, New York / Saint-Gaudens Memorial, Cornish, N.H.
Group Exhibitions: 144th Annual Exhibition of Painting and Sculpture, PAFA: *White River Settlement / Painting in the United States, 1949,* Carn.I.: *Country Horse Show.*

1950. In August, Sample and his Hanover friends Bob Stoddard and Sidney Hayward[21] went on a fishing trip to Labrador. They published their adventures, with watercolors by Sample, in *Field and Stream* magazine (July 1951).

Group Exhibitions: Pittsburgh International Exhibition of Painting, Carn.I.: *The Village Slope / American Painting Today,* MMA: *Remember Now the Days of Thy Youth* (cat. no. 48) / 125th Annual Exhibition, NAD: *Winter Holiday* (cat. no. 47).[22]

1951.
Solo Exhibitions: J. B. Speed Art Museum, Louisville, Kentucky / Vose Galleries, Boston.
Group Exhibitions: American Watercolor Society Exhibition, NAD: *Farm Hand in Yellow Chair* / 22nd Biennial Exhibition, CGA: *Winter Holiday* (cat. no. 47).

1952. In February Sample began his first assignment for the magazine *Ford Times,* published by the Ford Motor Company. His paintings appeared frequently in the magazine until his death.

In the mid-summer Sample and his friend Sidney Hayward went to Iceland for an extended fishing and sketching trip.

Honors: Served on the jury of selection for the 127th Annual Exhibition, NAD. Sample would serve on the jury of the annual exhibitions of the NAD almost every year until his death.
Group Exhibitions: 127th Annual Exhibition, NAD: *Tim in the Studio.*

1954. John Condit, a Dartmouth alumnus and a candidate for a Master of Arts degree in Art History at Columbia University, wrote a master's thesis, "Paul Sample," under the direction of Professor William Dinsmoor.

Honors: Served on a jury at the Worcester Art Museum.
Group Exhibitions: 129th Annual Exhibition, NAD: *Reveries of an Iceland Mariner.*

1955. At the request of his former classmate Sumner Kilmarx, Sample agreed to paint murals for the cocktail lounge at the Hanover Inn at Dartmouth College. Kilmarx, an interior designer, offered to donate his services as a designer if Sample would paint the murals gratis. Kilmarx later obtained a commission for Sample to paint murals for the Brevoort Hotel in Manhattan.

Commissions: Brevoort Hotel—four mural panels[23] / Ford Motor Company—five watercolors of ski scenes.
Solo Exhibitions: FUVM / The Bronson Museum, Attleboro, Massachusetts.

1956. In February the Associated American Artists Gallery closed and Sample joined the Milch Galleries in New York City. He continued to exhibit at the Vose Galleries in Boston.

In the early spring and summer Paul and Sylvia Sample traveled in Europe, where they were joined by Tim.

Group Exhibitions: 131st Annual Exhibition, NAD: *Iceland Fisherman.*[24]

1957. In April the artist and his wife visited Puerto Rico; and in August Sample and his friends went fishing in Labrador, where he made numerous sketches of the Indians and Eskimos.

In the autumn Sample began another mural, this time for the back bar of the same cocktail lounge at the Hanover Inn, showing his classmate and friend Bill Cunningham, a columnist with the *Boston Herald,* seated at a grand piano surrounded by vignettes of Dartmouth. Cunningham devoted a column to it in the *Herald* on April 8, 1958.

Awards: Henry Ward Ranger Fund Purchase Prize, 132nd Annual Exhibition, NAD. The painting, *Paisaje Español II,* was presented to The Fort Worth Art Museum (Texas).

1958.
Solo Exhibitions: Milch Galleries, New York.

1959. In March Sample was asked to paint a mural for the lobby of the National Life Insurance Company building in Montpelier, Vermont. The contract, signed in May, specified that the mural was to be installed by late February of the following year. Sample was to paint various aspects of the state of Vermont: the resources, the culture, the people, and the history, incorporating scenes from the history of the insurance company as appropriate.

The preliminary sketches were approved in late summer, leaving Sample less than six months to complete the project. He had no assistants except for his son, who helped him stretch and prepare the canvas. With the exception of two brief fishing trips to Labrador and Quebec with his son, Sample worked steadily on the mural in an effort to complete it by the promised date. But in November he had a heart attack, and he was unable to resume work on the mural until spring.

Group Exhibitions: 134th Annual exhibition, NAD: *Woodwind Group* / Century Association, New York: *Woodwind Group.* Sample exhibited

in the Century Association oil painting and watercolor exhibitions almost every year until his death.

1960. National Life could legally have terminated Sample's commission, but instead they chose to await the outcome of his illness. In May he returned to work on the mural part-time with help from Peter Gish, who had assisted him with the murals for the Brevoort Hotel. The young man spent the summer with the Samples; when he left, the mural was about half-finished.

Awards: Henry Ward Ranger Fund Purchase Prize, 135th Annual Exhibition, NAD: *Recuerdos de un Viejo II.*
Solo Exhibitions: Southern Vermont Art Center, Manchester.
Group Exhibitions: 155th Annual Exhibition, PAFA: *Paisaje Español* / 2nd Biennial Exhibition of American Painting and Sculpture, Detroit Institute of Arts: *Paisaje Español* / 135th Annual Exhibition, NAD: *Memories of an Old Man.*

1961. Sample completed and installed the National Life mural early in the year; it is still in place. At the dedication of the mural on March 5 Sample stated:

The work was developed always on an experimental basis. . . . Changes were made in accordance with unexpected color and form relationships which revealed themselves as the work progressed. Thus, the final solution was never stabilized until the final color stroke was made.

I might add that even directly after the mural was installed, I did make one or two minor revisions. I think it perhaps fortunate . . . that I do not live in Montpelier—for it is quite certain I should be tempted to go on to work once more on the revision of some passages on the mural.

The mural—Sample's largest project, 8 feet high by about 50 feet wide—was painted with "acrylic polymer emulsion paint," a relatively new medium. Sample liked the medium and wrote an article for *The Artist* magazine (63, 5: 102–3) on its use for mural paintings.

Following the dedication of the mural, the Samples traveled to Haiti, where Paul spent much of the time sketching. When they returned he resumed his informal classes at his studio in Carpenter Hall, but he found regular classes physically exhausting and reluctantly gave them up. He reached an agreement with the College

whereby he would retire in 1962 but continue to maintain a studio on campus.

1962. Sample and his wife sold their split-level house on Hopson Road in Norwich and purchased a large one-story house nearby.

At the end of July Sample received a letter from the president of the National Academy of Design soliciting comments and suggestions from the members regarding the declining status of the Academy.[25] His reply made positive suggestions that would have broadened the membership to include many of the so-called "abstract" artists:

> While I recognize that the National Academy has a worthy function of stability and of allegiance to sound tradition, I feel that this is a posture which must be tempered with an ever alert quest for outstanding artists whose work may be outside the seemingly accepted pattern of Academy standards. Such artists should be recognized and accepted as members. Our admission procedures would be adequate—providing the majority of our present membership could view sympathetically the necessity of adding elements of new vitality, force and vigor.
>
> September 17, 1962.

Although he was now officially retired from Dartmouth, Sample was given a studio in Hopkins Center, the College's new arts facility. At its dedication ceremonies Sample was presented with a second honorary degree.

Honors: Honorary Doctorate of Humane Letters, presented by Dartmouth College on November 18.
Awards: First Benjamin Altman Prize for Landscape Painting in Oil, 137th Annual Exhibition, NAD: *Port-au-Prince Marketplace.*[26]

1963. In January Sample moved his studio again, this time to his new home. In July he traveled to Twin Falls, Labrador, and in October he went hunting on the Ile aux Grues in Quebec.

Awards: Century Association Medal: *Jacob's Journey into Egypt.*
Solo Exhibitions: Retrospective exhibition at The Jaffe-Friede Gallery in the Hopkins Center, Dartmouth College / Milch Galleries, New York.
Group Exhibitions: 138th Annual Exhibition, NAD: *Jacob's Journey into Egypt.*

1964. In January Sample went to Cape Kennedy in Florida to prepare watercolors of a Saturn Rocket launch for the National Air and Space Agency (NASA). Following this assignment the Samples traveled in Florida, returning home in late spring.

In November Sample agreed to accept a commission for a mural from the Massachusetts Mutual Life Insurance Company of Springfield, Massachusetts.

Honors: Honorary Doctorate of Fine Arts, awarded by Nasson College, Springvale, Maine, on June 7.[27]
Solo Exhibitions: Nasson College.
Group Exhibitions: 139th Annual Exhibition, NAD: *Autumn Fisherman.*

1965. The details of the Massachusetts Mutual Life Insurance Company mural commission were confirmed, and the contract was signed in May. It was agreed that Sample was to paint two panels for the directors' dining room. One panel was to depict a street scene of Springfield from 1851, showing the early offices of the insurance company. The other panel was to be a landscape with Indians and early settlers in the Connecticut River area near Springfield. Sample worked on the sketches for most of the summer, and began painting in the fall. The murals were completed and installed by late December.

Sample continued playing the flute frequently, often in chamber ensembles with friends. He sent paintings regularly to the Vose Galleries in Boston. Late in the year, he returned with his son, Tim, to his favorite hunting grounds on the Ile aux Grues.

1966. Sample and his wife traveled to Yucatan during March and April. As usual he sketched constantly during his travels. When he returned to Norwich he continued work on his painting *Hunter in Landscape* (cat. no. 50), which had been commissioned in memory of Sidney Hayward, Secretary of the College, for the Hayward Lounge of the Hanover Inn. Prior to the dedication of the painting on June 14, Sample went fishing in Quebec.

Group Exhibitions: The Centennial of the American Watercolor Society, MMA: *Three Early Spring Anglers.*

1967. Sample continued painting at his home in Norwich, showing his work in New England, in New York, and at Capricorn Galleries in Bethesda, Maryland. He did not travel this year except for a trip in November to the Ile aux Grues. At the end of May, Harold Milch, Sample's New York dealer, wrote the artist that he was retiring.

Sample was still very much in demand for commissions and juries. He painted a landscape for the Governor of Vermont, John King, and was frequently asked to portray Dartmouth scenes and luminaries.[28]

Awards: Henry Ward Ranger Fund Purchase Prize, 142nd Annual Exhibition, NAD: *Still Life with Whistler.*
Solo Exhibitions: New Hampshire Art Association, Concord, N.H.

1968. Sample signed with Seward Eric, who was with the Van der Straeten Gallery in New York, while continuing to show his work at Capricorn Galleries and the Vose Galleries. He was invited by NASA to watch and paint the launching of another Saturn rocket, but had to decline owing to a bilateral hernia operation.

1969. Sample's health was failing. He declined a mural commission in January, and he canceled plans to sketch the Apollo launch for NASA scheduled for late February. In his letter to James Dean of the Space Agency, he stated: "I shall have to content myself in the hope that the results of my one trip to the Cape must stand as my sole contribution to the excellent NASA art project."

Although he suffered severe chest pains while at his summer retreat at Lake Willoughby, Sample continued to work on paintings for two forthcoming one-man exhibitions. After the opening of his exhibition at the Southern Vermont Art Center in September, he traveled to Montana on a fishing and sketching trip. When he returned he was commissioned by the Dartmouth Class of 1950 to paint a work as a retirement present for John Sloan Dickey, President of the College.

Awards: Century Association Gold Medal: *Northeast Kingdom.*
Solo Exhibitions: Southern Vermont Art Center, Manchester.
Group Exhibitions: American Paintings of Ports and Harbors, 1774–

1968, Cummer Gallery of Art, Jacksonville, Florida, and Norfolk Museum of Arts and Sciences, Norfolk, Virginia: *View of Baltimore Harbor* / American Watercolor Society Exhibition, NAD: *Old Man Drinking.*

1970. The artist was so delighted with the area surrounding Livingston, Montana, that he revisited the region with Tim in January. Montana scenery figured prominently in work Sample exhibited that year. The painting for John Sloan Dickey was completed by early April and was formally presented to the retiring president on April 16.

Solo Exhibitions: Vermont Technical College, Randolph Center, Vermont / Van der Straeten Gallery, New York.

1971. Sample granted permission to the UNICEF Greeting Card Fund of the United Nations to reproduce his painting *Northern Vermont Settlement* for a 1972 Christmas card, for which purpose it was retitled *Winter in Vermont.*

From mid-February until late April the Samples visited with friends in Destin, Florida, along the northern Gulf coast. Sample spent these two months sketching and fishing, his favorite occupations.

Although he was not seeking commissions, Sample was still frequently approached by Dartmouth alumni and others familiar with his work for scenes of Dartmouth and New England landscapes.

Late in the summer the artist received word that Seward Eric, his champion at the Van der Straeten Gallery, was establishing his own gallery, the Eric Galleries, in New York. Sample left Van der Straeten Gallery and joined the Eric Galleries, giving Eric exclusive rights to representation in New York but reserving the right to exhibit with his other dealers around the country.

Sample's paintings of the January 1964 Saturn Rocket launch appeared in Hereward Lester Cooke's book *Eyewitness to Space* (New York: Harry N. Abrams, Inc.), published on October 15. In the autumn he returned with Tim to Livingston, Montana, for four weeks of sketching and fishing.

Group Exhibitions: 146th Annual Exhibition, NAD: *Silent Country.*[29]

1972. Because of his failing health Sample declined to serve on the juries for the NAD Annual and a national competition in Rockport, Massachusetts. He suffered heart attacks in both March and April, and his activities thereafter were curtailed dramatically. He had to give up playing the flute, one of his great pleasures, and he painted only in the morning. Following the sudden death of his dealer, Seward Eric, Sample left the Eric Galleries and retained Capricorn Galleries as his primary dealer.

Commissions: The Environmental Protection Agency—a painting, *Montana Horses in the High Country,* delivered in 1973.
Solo Exhibitions: Capricorn Galleries, Bethesda, Maryland.
Group Exhibitions: Two-man exhibition (with Christopher Sanders, R.A.) at Eric Galleries, New York / 147th Annual Exhibition, NAD: *The Valley.*

1973. Sample spent most of the year in Norwich except for trips to his summer cottage at Lake Willoughby.

Solo Exhibitions: Watercolors—Capricorn Galleries.

1974. Sample continued his daily routine of sketching or painting in the mornings, often going out in the severe cold with his sketch pad. He told his wife he did not want to live if he could not paint. He had a heart attack after dinner on February 26, lost consciousness, and died shortly afterward. He had been painting earlier that day.

NOTES

I am indebted to Mrs. Sylvia Sample-Drury for permission to use the Paul Sample papers. My original research on Sample was done for a seminar in Art History; this work subsequently led to my master's thesis in Art History, "The Murals of Paul Sample," for The George Washington University, Washington, D.C., 1981.

1. Founded in 1916, the Wheelock Club was the largest eating club in Hanover, serving twenty meals a week (no Sunday breakfast, only brunch) at $7.00 a week per member. It served 120 members in two sittings, and there was a third sitting for staff and faculty.

2. The Barbary Coast Band was still in existence at Dartmouth in 1987.

3. Sample kept diaries at various periods during his life, including during his high school years; throughout his first year at Dartmouth College; from 1922 to 1928 (but not daily); during his first trip to Europe in 1938; from 1942 to 1944 (primarily during his assignments as artist-correspondent for *Life* magazine); and during his trip to Iceland in 1952. The Sample papers also include several notebooks and journals as well as extensive correspondence.

4. All prizes were for *Inner Harbor.* This painting was also exhibited at the 105th Annual Exhibition, NAD, in 1930 and at the Saint Louis Art Museum in 1931.

5. For additional information about the mural see my thesis, "The Murals of Paul Sample" (M.A., The George Washington University, 1981), pp. 27–31; much of the material is drawn from Shifra Goldman, "Siqueiros and Three Early Murals in Los Angeles," *The Art Journal,* 33: 321–27. Sample's correspondence also contains information on the mural. A photograph of the mural appears in *California Arts and Architecture,* July/August 1932, p. 2.

6. The mural was unveiled at a meeting to organize a branch of the New School for Social Research that took place at the Chouinard School. The New School (in New York City), as it is now known, was regarded in the 1930s as a haven for Socialists, Communists, and fellow travelers. It is tempting to speculate that Siqueiros chose the subject of his mural after learning of the occasion on which it was to be unveiled.

7. The Section of Painting and Sculpture of the Treasury Department was established as the part of the federal art patronage program that employed professional artists to decorate public buildings, regardless of the financial situation of the artist.

8. The paintings *Norris Dam* and *Apache Encampment* were shown at the 2nd Annual Exhibition, *Paintings by Artists West of the Mississippi,* of the Colorado Springs Fine Arts Center.

9. *Janitor's Holiday* (cat. no. 29) was purchased from the exhibition by MMA.

10. The citation from Lamentations V : 18 is: "Because of the mountain of Zion, which is desolate, the foxes walk upon it."

11. BIAA also purchased a watercolor by Sample, *The Milk Sledge.*

12. Sample was awarded the mural because of his design for *The Forty-Eight States (mural design) Competition,* the largest nationwide competition sponsored by the Section of Painting and Sculpture. The contest was for designs to decorate a designated post office in each of the states. The winning designs were made public in an exhibition which opened at the CGA on November 2, 1939, and were reproduced with the names of their designated post offices in the December 4 issue of *Life* magazine.

The post office designated for Vermont was in Island Pond, a small town not far from the family fishing camp at Lake Willoughby. Sample submitted his design for this post office, but it appeared in *Life* magazine as being for Westerly, Rhode Island. The design, now in the Hood Museum at Dartmouth College, was condemned by Westerly residents because it did not reflect the interests or activities of Westerly or its environs, and Sample was directed to make another design.

In the interim the community raised objections to the destruction of the old post office, which was to be replaced by a new building that was the destination for Sample's mural. As a result the construction of a new post office was delayed. With the advent of World War II the project was put aside and the mural was forgotten.

Some aspects of the Westerly mural design are discussed in Karal Ann Marling, *Wall-to-Wall America* (Minneapolis, 1982), pp. 161–71.

13. The seven others were *Farm in Vermont, The Milk Sledge, Fall Plowing, Haying, The Barns, Deans' Front Yard,* and *The River in March.*

14. Four paintings were exhibited at A.I.Ch.: *Between Classes, River*

in March, The Small Pond, and *White River Junction.* In the same year, 1940, Sample exhibited at the Philadelphia Watercolor Club Exhibition, PAFA, with four paintings: *The Small Pond, The White River, Snow in Central Park,* and *Lyndonville Fair;* and at the 5th Annual Exhibition, Colorado Springs Fine Arts Center, with *Whiskey for Jim's Cold.*

15. The citation from Matthew VI:19 is: "Lay not up for yourselves treasures upon earth."

16. *Going to Town* appeared in the May 1940 issue, *Spring Song* in the November 1940 issue, *Winter Visitor* in the June 1941 issue, and *Real Wealth* (cat. no. 55) in the October 1941 issue.

17. The American Tobacco Company commission was shared with three other artists: Aaron Bohrod, Lawrence Beall Smith, and Peter Hurd. The artists were to paint all aspects of the industry from the plants in the fields to the consumption of the finished product.

18. Also in 1942 Sample exhibited *Winter Visitor* at the 137th Annual Exhibition, PAFA, and *Matthew VI:19 (The Auction)* at the 3rd Biennial Exhibition of Contemporary American Paintings, VMFA.

19. The Pennsylvania scenes are watercolors and include *School Children in Independence Square, Devon Horse Show, Night, Skyline from the Philadelphia Museum of Art, Morning Shopping, Schuylkill River, Winter, Morning Arrival, Plant Workers, Industrial Scene on the Delaware River, Rittenhouse Square,* and *Logan Circle.*

20. He also exhibited *Norwich Holiday,* in addition to *Field Hospital in a Church,* at the 122nd Annual Exhibition of the NAD. The same year he exhibited *Still Life with Opera Hat* at the 6th Annual Exhibition of Audubon Artists, at the NAD.

21. Sidney Hayward, the Secretary of the College, died in 1965.

22. Sample also served on the jury of an exhibition at the John Herron Art Institute in Indianapolis. That year, 1950, he had a one-man exhibition at the Publick House in Sturbridge, Massachusetts.

23. The murals for the Brevoort were to depict the early history of New York City, i.e., New Amsterdam. The artist was assisted by his former students Peter Gish and Clyde Smith.

24. Sample also had a one-man exhibition at the Kimball Union Academy in New Hampshire.

25. Sample had been aware of this decline for some time. In his war diary for October 24, 1944, he wrote: "Barse [Miller] and I talked California art at breakfast. He has been recently voted into the National Academy and is pleased—but we both agreed that the Academy stinks to heaven."

26. This painting, which had also been exhibited at the Century Association in 1961, was subsequently purchased by BIAA.

27. Nasson College was closed in the early 1980s.

28. Among his correspondents in 1969–70 was Mrs. Erskine Caldwell, who wanted to commission a painting. In response to her later suggestion that Sample illustrate cats for her husband's children's book *Molly,* Sample wrote, "I may be able to strike up a friendship with a black and white cat during the summer, with secret designs on her for the model." (June 7, 1969.)

29. This painting was also exhibited at the National Midyear Exhibition at the BIAA in 1974, the summer following Sample's death.

Paul Sample
Painter of the American Scene

Robert L. McGrath

I hold no particular theories as regards painting. The most important thing for painters is to paint . . . and let others discuss and analyze. Many have read meanings and aesthetic qualities into my pictures which I was entirely unaware of . . . yet which seemed afterwards very logical and well considered, and I wish that I had figured them out myself.

— PAUL STARRETT SAMPLE, 1939

In 1934, approaching the apex of his career, Paul Sample was among the dozen most important artists in America.[1] By 1950 his art was all but forgotten, having been eclipsed on the national scene by the postwar triumph of Abstract Expressionism. This abrupt and virtually unprecedented reversal of critical fortune is part of one of the most fascinating phenomena of our recent art history. Paul Sample deserved better. The present exhibition attempts to document his art in a manner that will lead to a fuller appreciation of his achievement.

Early Influences

The broad stream that fed the art of Paul Sample was created by the confluence of numerous artistic tributaries during the first decades of the twentieth century. The earliest and most formative influence on Sample's art was that of the Norwegian-American painter Jonas Lie, whom Sample first encountered shortly after graduating from Dartmouth College in 1921. While convalescing from tuberculosis at Saranac Lake, New York, Sample began taking lessons from Lie as a means of combating the boredom of enforced inactivity. A member of the National Academy of Design, Lie practiced an idealistic mode of Neo-Impressionism devoted mostly to harbor and marine scenes and pastoral landscapes. The combination of Lie's painterly facility and his strong personality helped decide Sample upon the profession of artist in what seems to have been an overnight conversion, for he admitted that at Dartmouth he had slept through his only art history course. As his early works attest, and as he later avowed, Sample was influenced not only by Lie's academic style but also by his well-known aversion to modernist art. This aesthetic conservatism was congenial to Sample; he clung to it throughout his career, with both fortunate and unfortunate consequences.

Lie's harbor scenes are typically characterized by the heavy application of pigment to the canvas through Impressionist brushwork and coloration. Lie's active, painterly style, in combination with an interest in the play of light on water, clearly influenced the aspiring painter in such youthful work as *Fish Harbor* (cat. no. 3), painted in 1930. Yet one notes in this early, experimental

canvas that Sample was already more interested in formal patterning and decorative abstraction than Lie, who in such works as *Paths of Gold* (fig. 1) appears more conventional.

In the spring of 1925 Sample left the East for California to be near his dying brother Donald. After Donald's death from tuberculosis in June, Sample enrolled in the Otis Art Institute in Los Angeles and also attended classes and lectures at the studio of Stanton Macdonald-Wright. One of the first American abstractionists and a co-founder of the Cubist-derived Synchromist movement, Macdonald-Wright was a fervid apostle of non-representational abstraction. Sample, however, appears to have been relatively immune to the blandishments of the modernist aesthetic, for in a journal entry dated February 5, 1927, he noted:

This afternoon I listened to a talk on Modern art by Mac-Donald-Wright at the museum. He was fine. He appears to be extremely brilliant and is a talented speaker. But the peculiar part of it all was his attitude. He had a chip on his shoulder, was aggressively browbeating throughout and bullied his audience. It was delicious. He has lots to say and says it well. But I still do not appreciate Modern art.

In 1926 Sample gained employment at the University of Southern California teaching drawing to architecture students. This enabled him to continue his art studies and in 1928, on the eve of the Depression, to marry Sylvia Howland, a native of Vermont. His work of this period continued to display the influence of Lie both in style and in the choice of genre and landscape subjects, yet reflects an imagination still striving to discover a pictorial language and a point of view. In 1930 an early marine entitled *Inner Harbor* received an Honorable Mention at the annual Art Institute of Chicago exhibition. It was Sample's first important award.

Like most American artists of the period, Sample was strongly affected by the collapse of the stock market in 1929 and the subsequent onset of the Depression. Though he personally suffered only modest economic privation, thanks to his continued employment at USC, he began almost at once to reflect the altered economic

circumstances of the period in his choice of themes. The painting *Disagreement* (cat. no. 8) of about 1931, one of his earliest known figural compositions, shows a group of men observing a street corner fight. The sticklike figures, presumably representing recently idled workers, are crudely delineated with dashes of pigment against an architectural backdrop boldly conceived as a series of light-washed planes. This new mode of figurative genre represents an important shift for Sample. Rejecting the ideal world of nostalgic marine painting, he turned his attention, in a sequence of lively canvases, to the activities of the urban masses.

These paintings can be broadly characterized as "Social Realist" to the extent that they address contemporary urban life in America, especially the plight of the recently unemployed.[2] Unlike many of his East Coast colleagues, however, Sample never adopted a stridently polemical stance. His concern was more with observing the world than with reforming it, with making art rather than remaking society. There is simply no strong indication in the written or painted record that Sample ever thought of his art as a weapon for communicating social values. There is no evidence that he ever joined the Art Front, an artists' union, or any of the flourishing John Reed Clubs of the era. His journal entries from the time are surprisingly, even disappointingly, apolitical, concerning themselves primarily with literature, music, and sports.

Sample's first major canvas in the new reportorial style is the lively *Unemployment* of 1931 (cat. no. 9). In this witty and decorative work Sample displays for the first time his ability to handle a complex scene with numerous figures. The subject, as in *Disagreement,* is unemployed workers, but here the theme is treated with an animated, anecdotal sense of humor. A truncated composition of the Ashcan type and clearly allied to such urban realist compositions as George Bellows's *Cliff Dwellers* of 1913 (fig. 2), the work is more rigidly formalized than earlier efforts. The painting depicts a number of workers standing in front of an unemployment

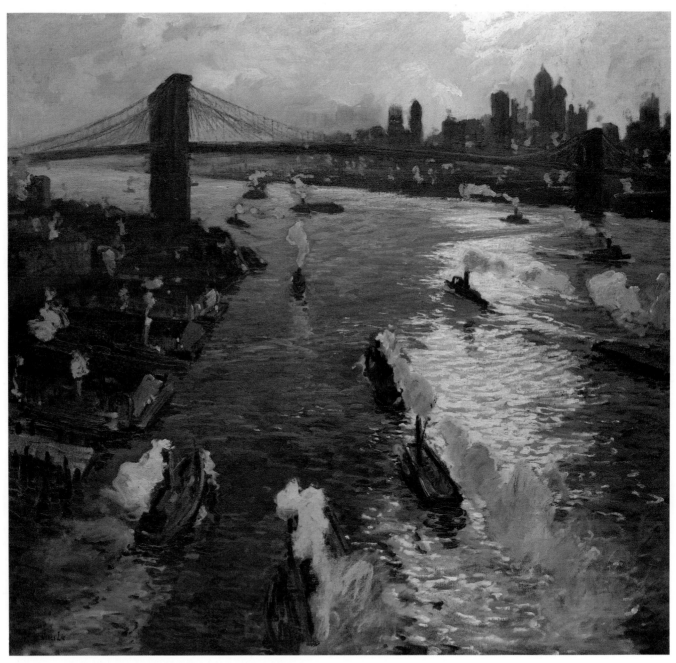

Figure 1. Jonas Lie, American, 1880–1941. *Path of Gold,* c. 1925. Oil on canvas, 34 × 36 inches. *The High Museum of Art, Atlanta, J. J. Haverty Collection.*

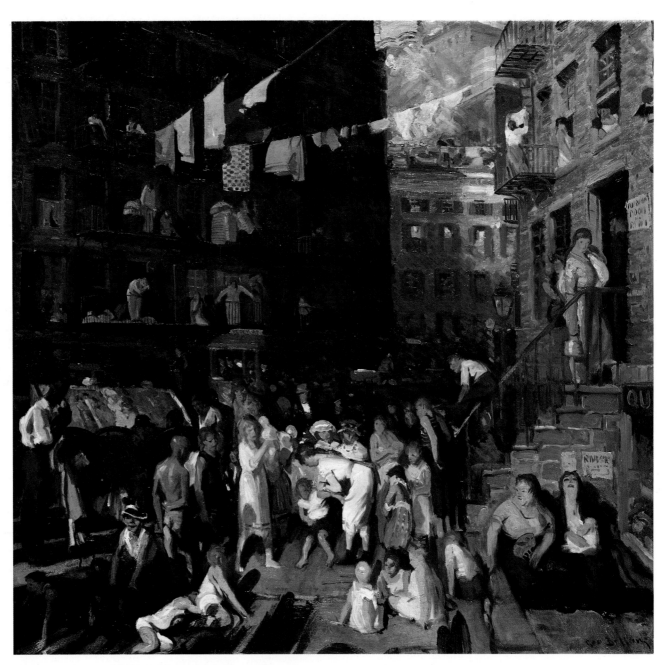

Figure 2. George Wesley Bellows, American, 1882–1925.
Cliff Dwellers, 1913. Oil on canvas, 39½ × 41½ inches.
Los Angeles County Museum of Art, Los Angeles County Funds.

30 *Robert L. McGrath*

agency and a church mission. In the foreground a fruit vendor and a black laborer square off in an argument while others chat idly, lean against telephone poles, or wait in line. Above the Agency and Mission, figures pull blinds and lean out of windows, and (shades of Manet's *Olympia*) a woman attends a black cat. The diminutive figures, painted in an expressionistic style bordering on caricature, are composed in small groupings that form an overall foreground triangle enclosed by two inward-leaning telephone poles. These in turn frame the composition laterally and unite the street scene with the buildings above. The colors are bright and clear, enlivened by the intense southern California light. These early Social Realist canvases are perhaps the first West Coast paintings of urban life in the recently designated American Scene movement.

Unemployment, always a favorite of Sample's, received the Isador Gold Medal at the National Academy of Design in 1932 and was later presented to the Academy on the occasion of the artist's induction in 1941. It is clear from a close look at this painting that Sample's interest lay more in the artistic challenges offered by an animated street scene than in the pressing social issues of his day. Although scenes of striking and unemployed workers came very much into vogue during the Depression years, forming as it were the iconography of Social Realism, Sample's work remained fundamentally optimistic, never aspiring to the more strident critical force of such East Coast painters as Ben Shahn, Nikolai Cikovsky, William Gropper, or the Soyer brothers. Less a document of hard times than a vigorous image of the street, humanity awash in warm California sunshine, Sample's painting benignly aestheticizes the content of Social Realism. In this respect *Unemployment* finds its closest analogy in the comic art of a film like Charlie Chaplin's *Modern Times,* another lighthearted yet poignant masterpiece of the Great Depression.

In 1930 the Mexican muralist David Alfaro Siqueiros, a Communist, was invited to Pomona College in California to execute a major fresco, and it may be that such

works of Sample's as *Disagreement* and *Unemployment* owed something to his encounter with Siqueiros. In 1932 Sample joined a number of painters to assist Siqueiros in the creation of a mammoth twenty-five-foot fresco for the sculpture court of the Chouinard Art School in Los Angeles entitled *Meeting in the Street* (fig. 3); others who helped were Millard Sheets, Barse Miller, and Phil Dike, all of whom were to become active during the 1930s as Social Realists. The fresco (now deteriorated) shows an orator on a soapbox haranguing a group of laborers.[3] This theme inspired Sample's *Speech Near Brewery* (cat. no. 11) of the same year, in which the orator's pose is clearly derived from the Siqueiros fresco.

In Sample's canvas the orator addresses a small and seemingly indifferent crowd about some burning political or social issue of the day. Although the pose of the orator derives from Siqueiros, the focus of the painting, characteristically for Sample, is not on the orator or the crowd but on the bold treatment of the stark walls of the brewery, boldly illumined by a sharp, raking light, that form the background of the painting. Stylistically this painting defies precise categorization, for although the genre element is to a large extent suggestive of the art of Social Realism, the treatment of the architectural motif—the regnant vision of the painting—is distinctly allied to the Precisionist movement, which had taken root in American art during the 1920s.

Precisionist industrial landscapes, of which *Speech Near Brewery* appears to be a distant relative, are generally seen as paeans to American industry. In the work of such painters as Charles Sheeler, George Ault, and Charles Demuth, the industrial landscape yielded an optimistic vision of American technology and functionalist design. In Sample's canvas, by contrast, it is unclear precisely where the artist's sentiments lie. Are we to view the brewery as a positive symbol of American enterprise, or, conversely, as a dehumanized backdrop to the social problems presented in the foreground? Perhaps both; it can be argued that *Speech Near Brewery* is

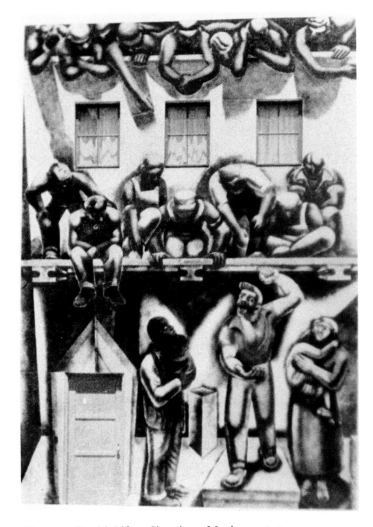

Figure 3. David Alfaro Siqueiros, Mexican, 1896–1974. *Meeting in the Street,* 1932 (deteriorated). Fresco, 24 × 19 feet. *Chouinard Art School, Los Angeles.*

Sample's rather engagingly eclectic attempt to reconcile Precisionist aesthetic interests with Social Realist topicality. In any case the formal mechanisms of the work take precedence over ideational issues, whether Precisionist or Social Realist.

Toward a Regionalist Style

Beginning in the early 1930s Sample and his wife began traveling each summer across the country by car to visit Sylvia's parents at their home near Montpelier, Vermont. These excursions, during which Sample made sketches to be worked up later in the studio, introduced the painter to several new regions, including the Southwest and the Rocky Mountains, and renewed his acquaintance with New England. They also served to expand his awareness of the spirit of the American landscape and his repertoire of nativist subjects.

Turning from themes of labor to those of rural genre, Sample's first important effort in this direction is the delightful *Church Supper* of 1933 (cat. no. 13). This painting, probably the earliest to be set in Vermont, depicts a typical small-town New England church supper set out of doors. At the center of the composition stands an elderly woman holding a tray; to the left and right the seated villagers are deployed along strong diagonals created by tables. Some of the villagers turn to stare at or speculate about some rather conspicuous intruders, notably a comely young lady entering the scene from the rear. An apparent outsider, she is of great interest to the men and an obvious source of displeasure to their wives. The whole is composed as a compact unity, creating a foreground triangle from the linked poses of the figures. *Church Supper* also reveals significant changes in Sample's use of both light and color. Forgoing the cheery, sun-washed California pastels of earlier years, he adjusts his palette to the New England environment, using a subdued scheme of earth hues with greens, browns, and yellows dominating. Lighting no longer possesses the flickering intensity of *Unemployment* but is

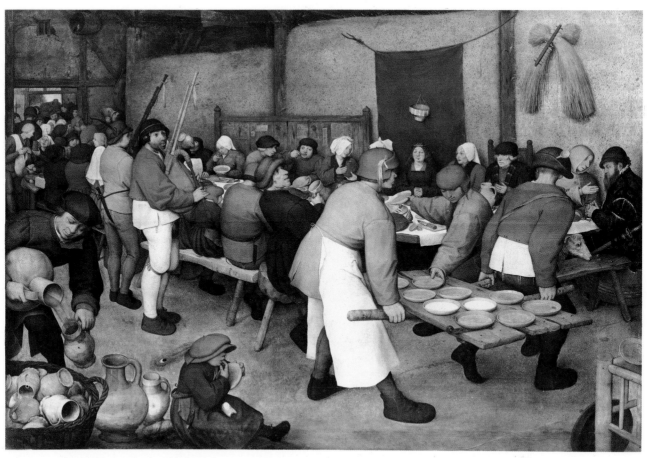

Figure 4. Pieter Brueghel the Elder, Flemish, 1525/30–1569. *Peasant Wedding Feast,* c. 1568. Oil on panel, 44⅞ × 64⅛ inches. *Kunsthistorisches Museum, Vienna.*

now employed as a broadly conceived *chiaroscuro,* modeling both the strongly conceptualized figures and the landscape forms with broad planes of light and shadow.

For the first time in Sample's oeuvre the figures dominate the setting; they are large-scaled, rounded, and somewhat pneumatic in appearance. The inspiration for this reductive large-figure style appears to have come from several sources. Among the most salient influences is that of Siqueiros, whose large, rubbery figures were themselves derived from the stereometric figural reductions of Cubism. Another probable inspiration is the recently formulated Neo-Primitive Regionalist style of the

Iowa painter Grant Wood, whose influence can also be seen in *Church Supper*'s ribbon-like roads, bulbous green hills, and geometric fields of crops.

Of equal importance is the art of the sixteenth-century Flemish painter Pieter Brueghel the Elder, whose *Peasant Wedding Feast* (fig. 4) affords strong grounds for comparison. Deployed along a similar diagonal *repoussoir,* Brueghel's robust peasants appear to be the Renaissance antecedents of Sample's rotund Vermonters. In both compositions the forceful diagonal movement is arrested by a single standing figure, and both artists view their respective scenes with amused tolerance for

these lusty "sons of the soil." From a high Brueghelian vantage, Sample composes his work in an eminently sophisticated manner, silhouetting the spherical heads and bodies of his figures against the arched openings of windows and the rounded hills in the background. The powerful diagonal thrust of the tables is repeated in the stark linearity of the architecture of the middle distance. The arms of the woman holding the tray in the center of the composition extend into the diagonals of the tables, creating a movement both forward toward the spectator and backward into space. Each of these principal compositional devices can be found in Breughel's work. Such self-conscious provincialisms as the tilting of the perspective plane for compositional effect, the rounded forms, the general clarity of tone, and the use of nonatmospheric earth hues are also derived from the Flemish master. Although Sample once claimed that he liked painting pictures much better than looking at them, *Church Supper* clearly derives as much from the study of the art of Siqueiros, Wood, and Brueghel as from the real world of Vermont farmers and church suppers.

Church Supper is significant not only as an example of Sample's first large-figure style painting, but also because it is the first work that can be placed under the general rubric of Regionalism. This portrait of small-town New England deals with the everyday life of country folk. It is not charged with strong social or political content, but rather amiably addresses the quotidian behavior of country people. Regionalism, loosely defined, was an attempt during the 1920s and 1930s by a number of artists, writers, and philosophers to replace the perennial blandishments of urban European culture with "an American way of looking at things." Rooted in the environmentalist philosophy of such thinkers as John Dewey ("locality is the only universal") and Lewis Mumford, and in the Southern nativist writings of John Crowe Ransom, Robert Penn Warren, and William Faulkner, Regionalism in its various manifestations looked to the land and its inhabitants as antidotes to the evils of the urban and technological world. Regionalists saw cities as "coffins for living and thinking," the decadent vestiges of failed modernism. The hope was to recover a kind of preindustrial innocence in the Eden of rural America.

Such cultural nationalists as Frank Lloyd Wright ("America begins west of Buffalo") and the Corn Belt Art Academy painters Thomas Hart Benton, Grant Wood, and John Steuart Curry viewed the Midwestern agrarian heartland as the real America and farmers as the nation's heroes. Sowers, harvesters, and threshers were cast in the roles formerly reserved for gods and athletes. Stressing the virtues of localism and democratic pictorial legibility over European formalist theory, the Regionalists sought to create an art "arguable in the language of the streets," one that would generally (though not consistently) provide a realistic and optimistic depiction of the land and its people.

The Rural Renaissance: Benton and Wood

Accompanying Regionalism's broad retreat from the gritty realities of urban industrialism into the pastoral utopia of agrarian myth was a simultaneous adoption of many of the pictorial forms and strategies of European Renaissance painting. As early as the mid-1920s Benton had turned to the works of such Mannerists as Tintoretto, El Greco, and Bronzino for his radically contorted figure and landscape style. Seeking a dynamic pictorial language to communicate his enthusiasm for America and the high energy level of its inhabitants, Benton consciously reverted to sixteenth-century forms and structures.

Soon afterward, following a 1928 trip to Europe, Benton's Iowa colleague Grant Wood developed a crisp, hard-edged style of Regionalist painting that has been called "the exact pictorial equivalent of the banalities of most people's lives and the clichés by which they live."[4] Wood's change from an Impressionistic style to one of linear realism was inspired in part by his admiration for the work of fifteenth-century Flemish primitives. Hans

Memling and Jan van Eyck appear to have exercised the greatest influence, with van Eyck's *Arnolfini Wedding* of 1434 forming the basis for such seminal Regionalist images as Wood's *American Gothic* of 1930. Finally, Curry, the last of the triumvirate, turned at about the same time in such works as *Tornado in Kansas* to the heroic figures of Michelangelo as models for his often beleaguered farmers.

Despite an avowed intent to ground their work in actuality and local experience, and in "direct representation rather than abstract introspection," there is obviously a strong art-historical component in the works of the Regionalists. For all their rhetoric and the special pleadings of their chronicler, Hearst columnist Thomas Craven, they typically produced pictures about pictures rather than realistic representations of rural life. If clarity, simplicity, and democratic legibility are in fact characteristic of their work, the impulse behind that work is not so much the ideals of rural life as those of the Renaissance Masters and the new European realists (notably the New Objectivity movement in Germany and Social Realism in both Germany and Russia).

The Brueghel Revival

With the adoption of the large-figure style in 1933, Sample turned increasingly to the work of Pieter Brueghel the Elder.[5] *Celebration* (cat. no. 16) of that year depicts a group of inebriated miners evocatively posed between derricks and set against a starkly eroded landscape. This combination of the new pneumatic Regionalist figure style with Social Realist content (labor, industry, erosion) is typical of Sample's protean sensibility at the time: "the deleterious effects of industrial labor,"[6] though surely hinted at, seem clearly less important to the artist than his continuing affection for Brueghel's engaging compositions. A comparison of *Celebration* with Brueghel's *Land of Cockaigne* (fig. 5) indicates the source of Sample's scheme. Rather than deploring modern labor conditions, Sample in fact wryly reformulates

Brueghel's statement concerning the soporific nature of a soft, idle life. At the same time his brilliant use of a quasi-abstracted eroded hillside is as much a comment on the corrosive function of alcohol on the mind as a polemic against industry for eroding the landscape. Sample's reduced and clarified landscape also bears a strong resemblance to the powerfully abstracted erosion series of the Texas painter Alexandre Hogue, another Regionalist who briefly influenced him at the time.

Sample's sustained affection for the work of Brueghel continued throughout the 1930s in such works as *Janitor's Holiday* of 1936 (cat. no. 29) and *Lamentations V : 18* (*Fox Hunt*) of 1938 (cat. no. 33), which can be compared respectively to *The Harvesters* (fig. 6) and *Hunters in the Snow* (fig. 7) from the Fleming's famous series of the seasons. In both of these works Sample, like Brueghel before him, inverts the structure of classical painting by putting nature in the center of the composition and humanity on the periphery.

At about the same time Grant Wood also turned to one of Brueghel's famous works, the well-known drawing *The Artist and Connoisseur* (Vienna, Albertina), as a source for his brilliant *Appraisal* of 1931, in which a farm woman and an overdressed urban Philistine are brought into revealing confrontation. Wood's acerbic self-portrait of 1935 entitled *Return from Bohemia* also reflects this same source, and to a milder degree Brueghel's implied criticism of society.

Although Sample and Wood played a major role in the Regionalist revival of Brueghel, they were anticipated to a considerable degree by the East Coast artist Molly Luce. This little-known painter of the American scene, who worked in both Pennsylvania and New England throughout the period, was in fact called the "American Brueghel" as early as 1925 by the art historian Alan Burroughs, whom she later married.[7]

A typical example of Luce's mature style is the large canvas entitled *Mining Country* of 1936 (fig. 8), which, like Sample's *Lamentations,* was inspired by Brueghel's *Hunters in the Snow.* In their respective works Luce and

Figure 5. Pieter Brueghel the Elder, Flemish, 1525/30–1569. *The Land of Cockaigne.* Oil on panel, 20½ × 30¾ inches. *Alte Pinakothek, Munich.*

Sample employ not only many of Brueghel's formal means (silhouetting, rhythmic groupings, universal lighting, simplified anonymous forms) but also the master's allegorical use of pastoral motifs to denounce industrial and social blight. Brueghel's scorn was for the spirit of material enterprise in sixteenth-century Flanders, Luce's for the behavior of the mining industry during the Depression era. As always, Sample's sentiments are not easy to ascertain.

In effect, it is possible to speak of a "Brueghelian period" within the broader context of the Regionalist Renaissance revival. More than any other painter, Brueghel seems to have struck a chord with the Regionalists. The quality of his powerfully reductive style, the resonant status of landscape within his oeuvre, and above all the unique character of his ironic vision held special meaning for a period of social upheaval, urban and industrial dislocation, and psychic disintegration.

A simplistic view of Regionalism as a form of pictorial America-first "boosterism" and Babbitt-like optimism still dominates much of the modest literature on American painting of the 1920s and 1930s. This view is sorely in need of revision. In point of fact, for every instance of Benton's and Wood's pastoral utopianism there can be found an equal and opposite dystopian vision in such works as Hogue's Texas erosion series and Curry's portrayals of Kansas as a tornado-ravaged wasteland.

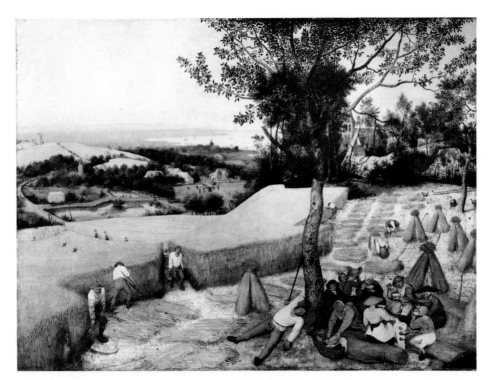

Figure 6. Pieter Brueghel the Elder, Flemish, 1525/30–
1569. *The Harvesters.* Oil on wood, 46½ × 63¼ inches.
The Metropolitan Museum of Art, Rogers Fund, 1919.

Figure 7. Pieter Brueghel the Elder, Flemish, 1525/30–
1569. *Hunters in the Snow,* 1565. Oil on panel, 46 × 63¾
inches. *Kunsthistorisches Museum, Vienna.*

The Resurgence of Rural New England

As previously indicated, the rise of Regionalism in art was to a large extent a function of Midwestern cultural nationalism. As *Time* magazine stated in 1934: "From Missouri, from Kansas, from Ohio, from Iowa, came men whose work was destined to turn the tide of artistic taste in the U.S."[8] Deliberately ignoring the fact that Benton was living in New York City and Curry in Westport, Connecticut, and that their paintings were far more fashionable in the urban galleries of Manhattan than in Joplin, Missouri, *Time* went on to commend these "earthy Midwesterners" for their "unadorned presentation" of native themes.

Just after the turn of the century the environmentalist historian Frederick Jackson Turner had proposed that the Middle West should be viewed as the core of American culture because it represented a mixture of the European-influenced East and the untamed West.[9] At about the same time, Owen Wister in *The Virginian* (1902) strongly contrasted the "pale decadence of New England" with the energy and virility of the frontier. Grant Wood himself railed against "quaint New England" in *Revolt Against the City,* published in 1935, where he advocated a struggle against the "colonial influence which is so deep-seated in the New England states."[10] Just as Emerson a hundred years before had repudiated the courtly muses of Europe, Wood from his Iowa bastion preached secession from the fallen and infected metropolis. Confidently he predicted the westward march of civilization from the Eastern seaboard to the agricultural heartland, and the progress of art from urban formalism to rural realism.

To be sure, New England had long viewed itself as the cradle of America, the source of moral, intellectual, and aesthetic probity for the nation. During the late nineteenth and early twentieth centuries, art colonies had flourished in Cornish and Dublin, New Hampshire, Provincetown and Gloucester, Massachusetts, and Old Lyme, Connecticut, as summer sanctuaries for urban artists. There was, however, no real commitment to the region *per se* in these early colonies. Another obstacle to establishing the newly emerging Regionalist culture in New England was the influence of the Boston Museum of Fine Arts School, which perpetuated genteel forms of Edwardian painting, the formal legacy of John Singer Sargent, well into the 1930s.

Yet things were stirring. Already in the 1920s such writers as Dorothy Canfield Fisher, Wallace Nutting, and Robert Frost had begun to reexamine the pastoral myth of the northern New England hill country. Rejecting the cultural dominion of Boston, they moved north to Vermont and New Hampshire in an attempt to discover agrarian truths in rural New England. Their rather uncoordinated efforts eventuated in such popular manifestations of culture as the founding of *Yankee Magazine* in 1935 at Dublin, New Hampshire, and the radio program *Town Meeting of the Air* (taking as its theme the Vermont town meeting as the central image of democracy), both of which further helped to define and promote the region in the popular imagination. Norman Rockwell's paintings of the *Four Freedoms,* created at Arlington, Vermont, in 1943, especially served to reaffirm the role of New England as the source of American democracy.

Regionalist painters soon appeared, notably Luigi Lucioni, Rockwell Kent, Andrew Wyeth, Molly Luce, and Paul Sample. Beginning in the early 1930s, Luce and Sample, independently of one another, began to delineate life in rural New England in terms of the broad canons of American Scene painting. Sample's first New England Regionalist work, *Church Supper* of 1933, was followed by two major canvases, *Janitor's Holiday* of 1936 and *Beaver Meadow* of 1939 (cat. no. 32). These two works, arguably his greatest paintings and among the most enduring images produced by Regionalism, not only established his national reputation but served to project what was to become an archetypal vision of the Vermont countryside into the American consciousness. In doing so he created seminal images of the agrarian Eden. *Janitor's Holiday,* his best-known and most famous work, contains all the elements of his mature

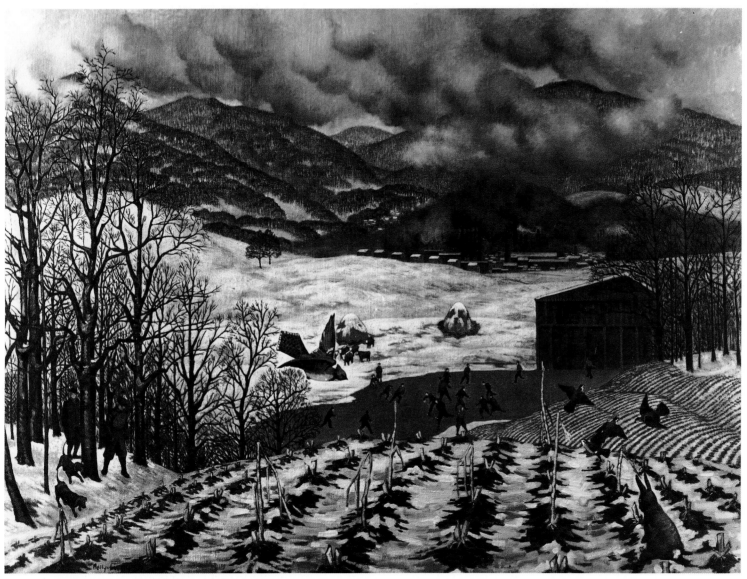

Figure 8. Molly Luce, American, 1896–1986. *Mining Country,* 1936. Oil on canvas, 36 × 48 inches. *Private Collection. Photograph courtesy of Childs Gallery, Boston and New York.*

Regionalist style. Lean and spare, carefully excised of all extraneous detail, it provides a vision of organic harmony between man and the natural environment. Loosely inspired by Brueghel's *The Harvesters,* it depicts a tightly ordered New England landscape, humanized by the activities of harvesters living close to the land and responding to its rhythms and patterns. The well-regulated fields and houses afford a vision of humanistic self-reliance and pastoral wholeness.

Only the awkward and somewhat despondent figure of the resting janitor in the foreground appears out of touch with the scene. Conforming to the basic tenets of polemical Regionalism, the janitor, a symbol of urban life, is unfavorably contrasted with the natural labor of farmers. Privileging the country over the city and nature over culture, Sample affirms the primacy of natural over human time. The peculiar New England inflection of the work—it was painted near Montpelier, Vermont—resides in the softly rolling and wooded hills and the stark chromatic scheme of yellows, browns, and pale greens. The sparse land and palette contrast strongly with the bright, florid greens of, for example, Grant Wood's Iowa idylls, with their sensuous, breast-like landforms.

Sample's agrarian world is not dominated by machine technology or other artifacts of the era's incipient agribusiness; rather it is characterized by the craft and precision of manual labor and by men working in collective harmony. In a related manner Sample's spare and tightly rendered forms, which reveal no evidence of painterly brushstroke, are analogous to the tight-lipped, rock-ribbed speech and behavior of the mythical Vermont hill farmer.

Beaver Meadow, which comes near the end of the period of Regionalist cultural hegemony, affords a more complex, even somewhat enigmatic, image of Arcadia. The foreground figures stare passively in opposition to one another. Their obvious alienation from the splendor of the landscape is unsettling. Intended to represent the Sabbath in rural Vermont, the canvas also juxtaposes a horse and carriage with something new and intrusive,

the automobile. Sensing the collapse of 1930s ideology (redemption through community and interdependence rather than competitive individualism), Sample introduces elements of alienation and disintegration into one of his most profoundly evocative works. His mastery of the Regionalist aesthetic, his capacity to compose and orchestrate the figural and landscape elements into a striking unity, the graphic quality of strong forms silhouetted against the starkly reductive fields, have never been more fully brought to bear. In this splendidly resonant canvas we encounter the artist in full possession of his resources, the Regionalist vision in its most compelling form.

Something of this same force carries over into the more anecdotal *Matthew VI:19 (The Auction)* of the same year (cat. no. 34). A decidedly less ambivalent work than *Beaver Meadow,* it celebrates the frugal economy of rural New Englanders and cautions us not to store up "treasures upon earth, where moth and dust doth corrupt." The apparition in the sky of the recently deceased together with his dog (the traditional funerary symbol of fidelity) lends an interesting spectral quality to the scene of a country auction. The conspicuous presence of paintings among the items to be auctioned further underlines the Regionalist conviction that art must be intelligible to the people to be useful, and that it should be affordable to the common man.

As one of Sample's most eloquent winter scenes, *Mathew VI:19* does not present the traditional idealized vision of nature that had dominated the American landscape tradition since the nineteenth-century Hudson River School. Like the Texas Regionalists, a splinter group with whom he has some clear affiliations, Sample often depicted nature during the 1930s as a product of erosion, or, more typically, as cold, harsh, and indifferent to man. This sensitivity to climate and to season was to remain a critical element of his art throughout his career.

A final allied work, *Maple Sugaring* (cat. no. 42), was painted in 1944, well after Regionalism had reached

its apogee. This crisply graphic winter scene contains many of the usual elements of Sample's mature style, notably enframing trees, genre elements, universal lighting, and a high horizon. Here, however, the figural element has been attenuated and reduced in relation to the more angular setting, making the painting a clear instance of his late landscape style.

Maple Sugaring is Sample's most widely circulated image owing to its frequent reproduction and its use as a logo by a major Vermont maple syrup producer for over forty years. Affirming the value of individual labor in an age of mass production, it projects an image of rural self-sufficiency that still forms the core of pastoral mythology. An icon of Vermont rural industry, *Maple Sugaring* is one of Sample's most authoritative images.

The Documentary Realist

With the election of Franklin Delano Roosevelt in 1932, the art of the American Scene movement was adopted by the administration as an appropriate visual expression of its social and economic programs. That a progressive, liberal administration eagerly sponsored what today is often thought of as a regressive and reactionary art is one of the paradoxes of recent cultural history.

The history of the Works Progress Administration / Federal Arts Project (WPA/FAP) is too well known to bear repeating here. Sample painted his share of New Deal murals in post offices and government buildings. At the same time, he also received frequent commissions for illustrations from such bastions of capitalist enterprise as *Fortune* and *Life* magazines. This seems to have caused him no particular anxiety, since (as we have seen) he was in no way committed to an art of radical social protest.

Among his commissions were paintings of American ports as well as a spectacular portrait of *Norris Dam* painted in 1935 (cat. no. 26). One of his first works for *Fortune,* this painting provides an aerial view of the pro-cess by which the agrarian past was being transformed into the New Deal present under the aegis of the Tennessee Valley Authority. Like Pare Lorentz in his great documentary film of the same year, *The River,* Sample extols the virtues of controlling nature for the benefit of society. If there is any intended irony in the work, it is only that the peaceful valley and the well-ordered village will soon be under water.[11] This loss, however, appears to be offset by the bustling activity of the antlike mob of workers who have found meaningful employment under the New Deal. Sample's glorification of the dam also reflects the collaborative ethos and mass aesthetic of the period.

Stockton Harbor (cat. no. 27) is one of eight paintings of American ports commissioned by *Fortune* as illustrations for an article on maritime commerce ultimately published in 1937. This carefully composed canvas shows Sample in full control of his documentary resources. The extreme aerial perspective and crisp detailing suggest that he may have worked from photographs as well as from direct observation. Whatever his sources may have been, he consciously emulated the sharp-focused aesthetic of documentary photography, which was then gaining artistic recognition as a major art form. A contemporary critic noted that "this interest in objective fidelity gives the effect of photographic realism, an amazing accomplishment in respect to the technique but hardly worth the painstaking effort whose achievement lies within the sphere of another art."[12] The point is not well taken, since it was precisely Sample's intent to use the aesthetics of photography to enhance the documentary effect of his painting.

These harbor scenes bear neither a formal nor an iconographic relationship to Sample's harbor scenes of a decade earlier. The earlier paintings, inspired by the Impressionist vision of Jonas Lie, are products of a nostalgic imagination and a loaded impressionist brush; the *Fortune* paintings are lucid, factual, and modern. The composition of *Stockton Harbor* is the most dynamic so far encountered in Sample's oeuvre, being laid out along

two bold diagonal axes that intersect at the lower edge of the canvas. This *a priori* abstracting of a scene anticipates the direction that his work will take in subsequent decades.

Paul Sample at Dartmouth

Riding the crest of his national popularity, Sample received an honorary degree from his alma mater Dartmouth in June of 1936. This was followed by a sabbatical leave from USC and a year spent traveling in Europe. Visiting major art museums, Sample was finally able to view paintings by the European masters that he had heretofore seen only in the form of prints or reproductions. On returning from Europe in 1938 he was offered the recently created post of artist-in-residence at Dartmouth, a position he was to hold until 1962, with the exception of two wartime years.

Commenting on this appointment in *Art Digest,* the critic Peyton Boswell, a longtime supporter of the Regionalist movement, noted that this provided "Eastern sanction to a Midwestern contribution in education."[13] Boswell was referring to John Steuart Curry's appointment in 1936 as artist-in-residence at the University of Wisconsin, which he mistakenly cites as the first instance of the practice in the history of American academe.[14]

During his long career at Dartmouth Sample offered courses in painting and drawing for students and other members of the community on a noncredit basis. These courses were always popular and well-attended. Owing to his statuesque appearance and reserved manner, Sample inspired a certain awe among students and faculty alike. His growing national reputation, as well as his service on jury panels for such august institutions as the Corcoran Gallery and the Metropolitan Museum of Art, further served to establish his position at the College.

The Surrealist

Most previously discussed works by Sample are firmly grounded in the empirical world, albeit one often subjected to a process of conceptualization and abstraction. Fanciful and preternatural events were generally excluded from the artist's normative world of laborers, farmers, performers, and animals.

As early as 1934, however, Sample created a phantasma of sickness and frustration that the critic Alfred Frankenstein called at the time "as sinister and tormented as any vision of Flemish hell."[15] The painting entitled *Ward Room* (cat. no. 17) appears to be autobiographical, doubtless referring to the artist's confinement at Saranac Lake from 1921 to 1925. The stark, high-ceilinged room, illumined by a simple light, is adumbrated by a cold, nearly monochromatic color scheme of grays and whites. Patients, lined up like inmates in an asylum, display varying states of boredom, frustration, and helplessness. At the end of the room an arcaded opening reveals, in the Flemish manner, a street bustling with the activities of city dwellers. The tilted, raking angle of this street scene contrasts with the normative perspective of the room, establishing a disquieting sense of uncertainty. Both the subjective, dreamlike imagery and the distorted spatial construct derive less from the real world than from the occluded compositions of such American narrative Surrealist painters as Louis Guglielmi.[16] Based on the ideology and deliberate ambiguities of narrative Surrealism, *Ward Room* is one of Sample's most evocative works, conjuring up a full gamut of disturbing anxieties.

An even more nightmarish vision of physical and psychological torment is the violently hallucinatory *Field Hospital in a Church* (originally known as *Delirium Is Our Best Deceiver*) of 1944 (cat. no. 45), which was painted in the Philippines while Sample was on duty as an artist-correspondent for Time-Life, Inc. Set in the interior of a Baroque cathedral that was being used as a field hospital for U.S. Army victims of malaria and other jungle fe-

vers, it depicts the contorted bodies of the diseased in various poses of writhing delirium that uncannily echo the violent contortions of a sixteenth-century Netherlandish *Last Judgment*. The ordeal of the diseased soldiers is accentuated by its context: the mundane activities of civilians attending mass before a Baroque altar or performing routine duties. Wild distortions in scale separate the visionary world from the actualities of the sick ward. Expressively attenuated Benton-like forms of the ill are further contrasted with the more conventional proportions of civilians. Based on Sample's confinement in a field hospital for a sprained ankle, the canvas is further enlivened by flickering light, somber coloration, and a Bosch-like expressive intensity. This extraordinary work is one of Sample's most individualistic efforts and is among the most enigmatic paintings produced during World War II.

The War Correspondent

With America's entry into World War II, the national ethos was once again radically transformed. Isolationist politics and aesthetics yielded to a renewed internationalism, and both Regionalism and Social Realism went rapidly out of style. Sample's response to this abrupt transformation of the political and cultural climate was typically adaptive as he once again altered his vision and aesthetics to conform to the changed circumstances of a country at war.

Shell Factory of 1941 (cat. no. 39) provides a new vision of American labor and mass production. Painted in a bright dichromatic scheme of yellows and blues at the Budd Wheel Works in Detroit, a factory converted for war production, it shows the product rather than the actual process of labor. Dramatically actualized by the strong diagonal thrust of the shell casings, the painting provides sharp contrasts of scale in foreground and background forms. The principal aesthetic impulse is the abstracting of the elements of design to effect a strong composition based on the repetition of identical shapes.

Broadly anticipated by such works as *Stockton Harbor* and *Tobacco Auction* (cat. no. 40), which is based on a similar plunging Mannerist breakneck perspective, *Shell Factory* reveals the general direction of Sample's postwar aesthetic. This painting, like much of his wartime production, was commissioned by Time-Life for eventual reproduction in *Life* magazine.[17]

In 1943 and 1944 Sample toured the Atlantic and Pacific theaters of combat as an artist-correspondent for Time-Life. Illustrations from one of his many assignments, a secret mission on board a submarine in the Central Pacific, were published in *Life*'s 1943 Christmas edition. The bulk of his work at this time was executed in watercolor, a medium that he first took up in the early 1930s and turned to increasingly in later years, especially for journal assignments. His striking command of this medium served him well during the war. His work was frequently reproduced in *Life* in the wartime years, affording viewers insight into the activities of soldiers and sailors, especially in moments of leisure or in noncombat situations; a good example is *Central Pacific Arrival* of 1943 (cat. no. 59). Among his most spontaneous creations, the wartime watercolors show Sample less as a studio artist than as an inquiring journalist, open to experience and prepared to develop interesting reportorial compositions.

The Late Years

With the demise of Regionalism and Social Realism during the 1940s, Sample found himself suddenly excluded from the mainstream of American art. The artist who had been among the most influential in formulating the national vision during the Depression era was suddenly confronted with the prospect of artistic oblivion.

Unlike several of his fellow Regionalists, Sample was unable to effect a transition from a nativist style and content to the newer, international modes of self-expression and abstraction that began to dominate the art scene

in postwar America. He remained antagonistic toward nonrepresentational art and theory. Though he continued to exhibit in New York from 1943 to 1956 with Associated American Artists, he had nothing in common with the painters of the emerging New York School. A respected Academician (elected to full membership of the National Academy of Design in 1941) and the object of museum retrospectives (Currier Museum of Art, Manchester, New Hampshire, 1948; J. B. Speed Museum, Louisville, Kentucky, 1956), Sample was nonetheless out of tune with the times.

As previously noted, Sample had already begun to experiment with more abstract compositional modes as early as the 1935 series of paintings of American ports. A small landscape of 1937 entitled *East Charleston School, Vermont* (cat. no. 30) further developed this penchant. Perhaps the earliest work of his in which the figures and the architecture are greatly reduced in scale in relation to the natural setting, this canvas also reveals pronounced changes in style and brushwork. In lieu of the tight, sharply outlined forms of the Regionalist aesthetic, Sample began once again to loosen his brushwork and to apply pigment to the canvas with a heavily laden brush. The even, universal lighting of such works as *Janitor's Holiday* yields to a flickering and fluctuating, more fluid light that highlights forms rather than adhering to their full rounded contours. This Neo-Impressionist style, which tends to focus on the rich phenomenology of nature rather than its conventional or symbolic forms, stands in marked contrast to the narrative and formal modes of the Regionalist aesthetic. Where the Regionalist style had sought to fuse the relationship between man and his environment—the dialectic between Nature and Culture—the Neo-Impressionist style seeks to evoke contemplation or reflection upon the natural world. Where Regionalism is often informed by a program of social content, in Sample's late landscape style topicality, readability, and narrative anecdote give way to a generalized landscape sentiment.

This retreat from the particularities of Regionalist social comment into the generalities of pastoral vision is accompanied by a strong impulse to abstract the landscape forms. This can be seen to fullest advantage in such characteristic examples of the late style as *Sharon's Sleigh Ride* of 1941 (cat. no. 41), *Hunter in Landscape* of 1966 (cat. no. 50), and *Hackleboro Farm* of 1968 (cat. no. 49), to cite only a few examples from a vast corpus. In each of these paintings the landscape is reduced to a broadly conceived abstract structure composed of layered and intersecting arcs, triangles, and rectangles. Each of these separate geometrized areas is now indicated by differing brushstrokes; where houses, barns, and churches appear, they are no longer represented in the Regionalist way but under the completely different conditions of Neo-Impressionist lighting.

Like the great Post-Impressionist Cézanne, Sample now sought simultaneously to suffuse the landscape with light and color and to make its component parts cohere in an abstract, nearly geometric surface design. Sky and land became more vital in the overall composition of his paintings, resonating in harmony with other natural forms rather than serving as the backdrop to human activity. Moreover, whereas throughout his career Sample relied on the academic method of working up finished studio paintings from *plein air* sketches, the late landscapes provide more the appearance of immediacy and direct observation than his earlier paintings.

Despite Sample's efforts to adjust his vision in the direction of surface abstraction, his status with the broader national audience continued to decline. By the early 1960s his work possessed only limited appeal outside of New England. Unlike his fellow Regionalists Wood and Curry, who died in the 1940s, or Benton, who stubbornly railed against modernism in both word and paint until his death in 1975, Sample effected a partial compromise with modernist aesthetics; but for all its charm his late style found little favor.

From the vantage of current art history we can now

look back on the painting of the 1930s as representing the period when Sample's art was most congruent with national sentiment, when, in effect, he helped to shape that sentiment. The present reevaluation of the period, of which this exhibition is a manifestation, suggests that Sample's Regionalist works in particular, largely ignored until the 1980s, will form his most significant and enduring contribution to the history of American art.

Remember Now the Days of Thy Youth

The magistral painting *Remember Now the Days of Thy Youth* (cat. no. 48) is one of Sample's most poignant and evocative works. Painted in 1950, after his fall from critical grace, it functions both as a kind of spiritual autobiography and as an anthology of the styles that had dominated the art of prewar America. The scene is observed through the eyes of the old men in the foreground, who serve as surrogates for the viewer: it is a world bifurcated equally between the artifacts of culture and the organic forms of nature. As one of the sustaining institutions of Sample's early vision, human culture is denoted by houses, factories, a smokestack, and a water tower. A bridge carries the eye into the middle distance at breakneck speed and simultaneously divides the composition. The left side is painted in a stark, reductive manner redolent of the Precisionist and Social Realist periods; the right side, the realm of nature, is depicted in a looser, Neo-Impressionist style. The creaky mansard-roofed house on the hill is a portrait of a home in Hartford, Vermont, which at the time of this painting functioned as a nursing home—its porch here displaced into the foreground of the painting. The Regionalist-inspired foreground figures include a portrait of Sample's farmer-neighbor Will Bond (also the subject of the portrait *Will Bond*, cat. no. 38). Sample's sympathy and affection for old people is one of the most consistent and characteristic features of his art. These venerable elders look out upon a symbolic springtime,

staffed with perambulating mothers, young lovers, and casual strollers. A deeply personal reflection on the passage of time, this work not only displays the full gamut of Sample's pictorial resources but offers a final statement of his role in the history of American art.

NOTES

1. In the Christmas issue of *Time* magazine for 1934 an epic article appeared on Regionalism, citing Thomas Hart Benton (whose self-portrait was reproduced on the cover) as the leader of the movement and Paul Sample and Millard Sheets as "the best of the West."

2. See Howard E. Wooden, *The Art of the Great Depression: Two Sides of the Coin* (exhibition catalogue; Wichita, Kansas: Wichita Museum of Art, 1985), for a thorough discussion of Social Realism.

3. See "California Group Studies Fresco Technique with Siqueiros," *Art Digest* 6 (August 1932), p. 13.

4. Matthew Baigell, *A Concise History of American Painting and Sculpture* (New York, 1984), p. 264.

5. See "Paul Sample Who Worships Peter Breughel," *Art Digest* 8 (May 1934), p. 8, which cites Sample as follows: "Peter Breughel the Elder is my favorite painter of all time, although I have seen very few of his paintings except in reproductions." A letter of August 26, 1949, to his son tells of a visit to the Detroit Institute of Art: "The Art Institute is right next door so after I finished I went in to see my favorite Brueghel (*Peasant Wedding Dance*). I spent twenty minutes in front of it. It's a real beauty." An article in *Art in America*, March 1937, p. 17, refers to the Regionalists as "the Pieter Breughels of our time who paint ugliness and colorlessness, beauty and charm with much the same amused tolerance." See also the important article by Alfred Frankenstein, "Paul Sample," *Magazine of Art* 31 (1938), pp. 387–91. According to Frankenstein, "Sample declares he is possessed of no special credo or theory, but regards Brueghel as the greatest master of all time."

6. Nancy Heller and Julia Williams, *The Regionalists* (New York, 1976), p. 48.

7. Alan Burroughs, "Young America, Molly Luce," *The Arts* 8 (1925), pp. 114ff. Cf. also D. Roger Howlett, *Molly Luce: Eight Decades of the American Scene* (exhibition catalogue; Boston: Childs Gallery, 1980).

8. *Time* 24 (Dec. 24, 1934), p. 24.

9. See Mariea Candill, *The American Scene: Urban and Rural Regionalists of the 30s and 40s* (exhibition catalogue; Minneapolis: University Gallery, University of Minnesota, 1976), p. 8.

10. Grant Wood, *Revolt Against the City* (New York, 1935), p. 130.

11. See Michael J. McDonald and John Muldowney, *TVA and the Dispossessed* (Knoxville, Tennessee, 1982). Elia Kazan's film *Wild River* of 1960 also deals with the theme of dispossession.

12. Cited in John Haletsky, *Paul Sample, Ivy League Regionalist* (exhibition catalogue; Miami, Florida: Lowe Art Museum, University of Miami, 1984), p. 35. See also Alfred Frankenstein, *op. cit.*, p. 391: "There is also a separate chapter in Sample, the literal realist, who can photograph a scene on canvas with a perfection of crystalline detail only equalled by [Charles] Sheeler, the ex-photographer."

13. Peyton Boswell, "Ivy League in Art," *Art Digest* 12 (February 1938), p. 3.

14. Other institutions preceded Wisconsin in establishing artist-in-residence programs. In 1915 Vassar College invited the painter Clarence Chatterton to serve as artist-in-residence, a position he held until 1948. At Dartmouth the Mexican muralist José Clemente Orozco filled such a post from 1932 to 1934, during which time he completed his great mural cycle *The Epic of American Civilization*. Orozco was followed by the Canadian painter Lawren Harris, who maintained a studio on the Dartmouth campus from 1934 to 1938.

15. Cited in John Haletsky, *op. cit.*, p. 28.

16. See *American Realists and Magic Realists* (New York, 1943), pp. 38–39.

17. *Life* 15 (Dec. 27, 1943), p. 54.

Catalogue of the Exhibition

In all listings of dimensions, height precedes width. Works are listed in two categories: Paintings and Works on Paper. The order is roughly chronological within categories, but often design considerations or the desirability of grouping works stylistically argued against a strict adherence to chronology. The Index of Works in the Exhibition at the end of the catalogue will help locate specific pieces.

Paintings

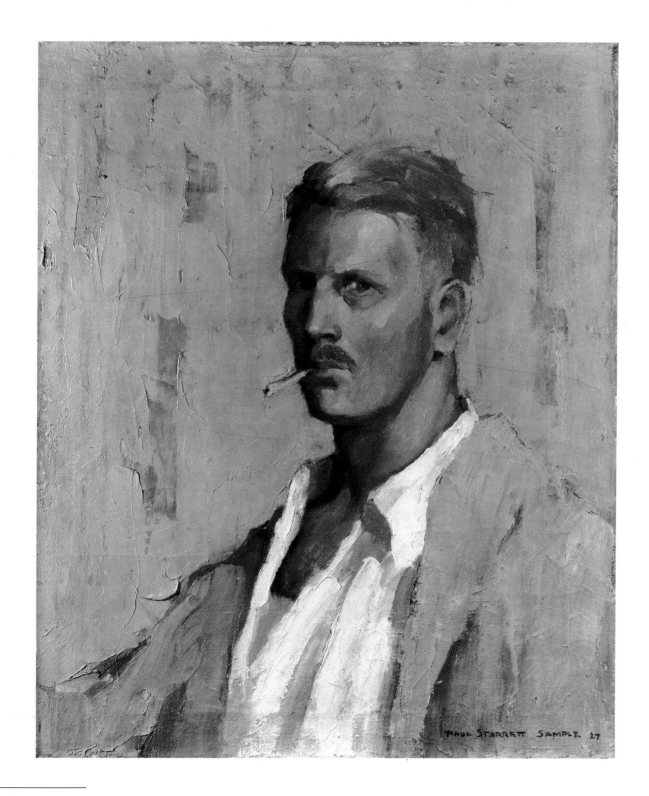

1. *Self Portrait,* 1927

Oil on canvas, 24 ¼ × 20 ⅛ inches
Hood Museum of Art, Dartmouth College
Gift of the Artist

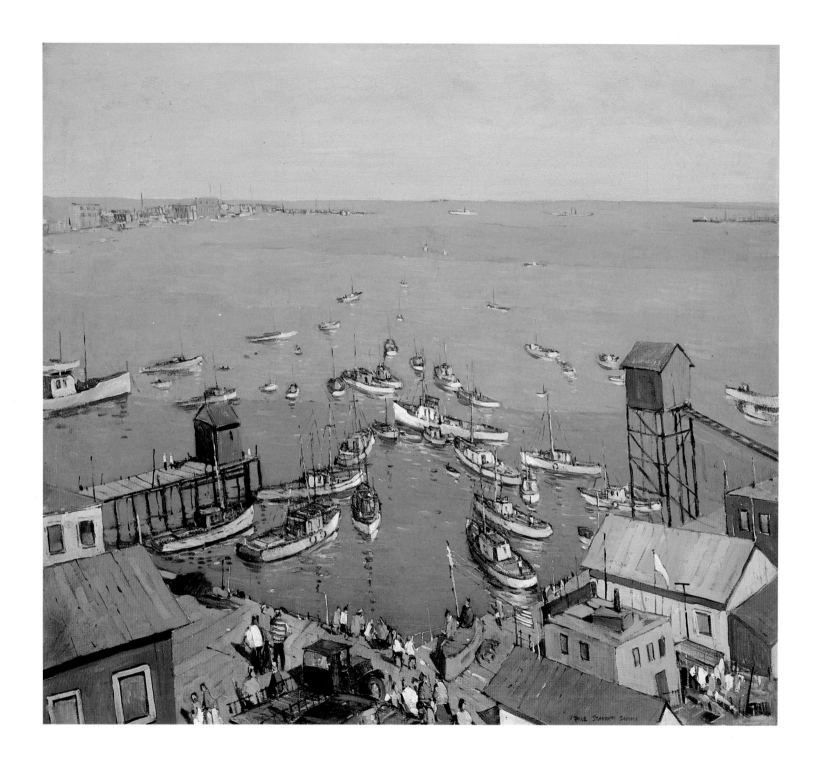

2. *Blue Harbor,* c. 1930

Oil on canvas, 35 × 40 inches
Hood Museum of Art, Dartmouth College
Gift of the Artist

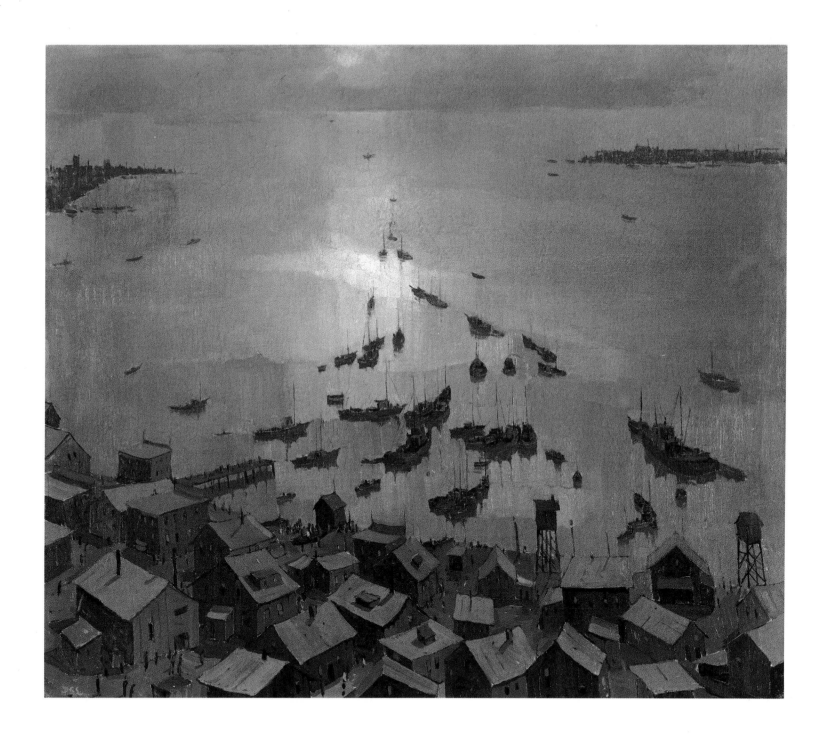

3. *Fish Harbor,* 1930

Oil on canvas, 34 × 40 inches
T. W. Wood Art Gallery, Montpelier, Vermont

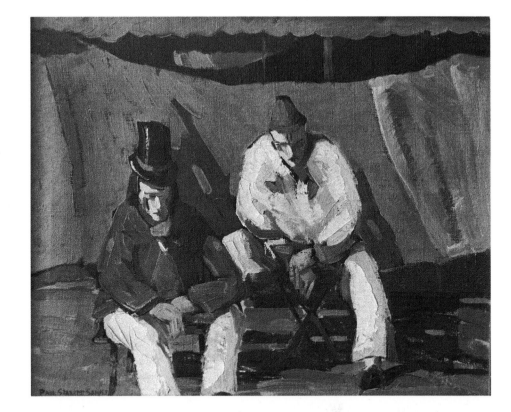

4. *Clowns Resting*, 1929

Oil on canvas, 15¾ × 20¼ inches
Private Collection

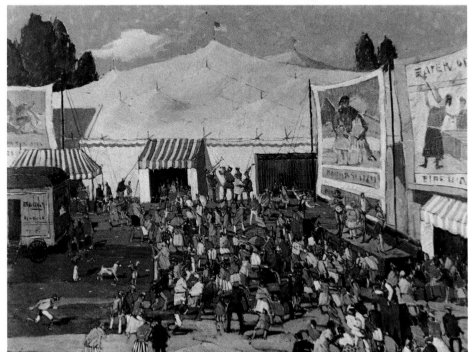

5. *The Country Circus*, 1929

Oil on canvas, 36 × 48 inches
Swarthmore College

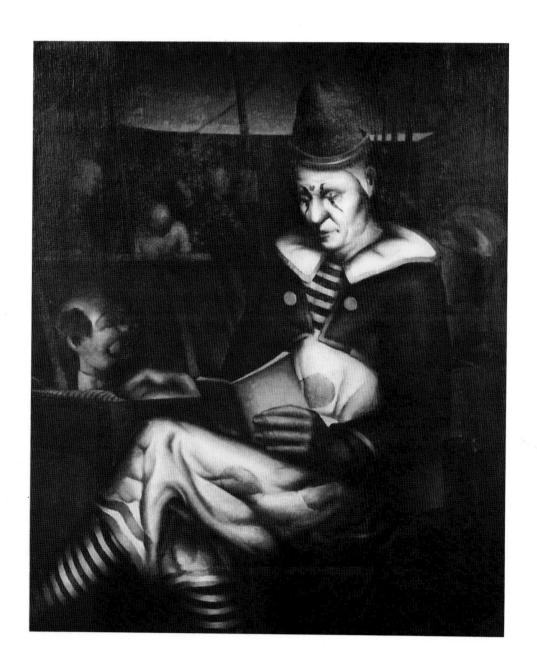

6. *The Clown* (*Clown Reading*), 1933

Oil on canvas, 25 × 30 inches
Audrey Chamberlain Foote, Washington, D.C.

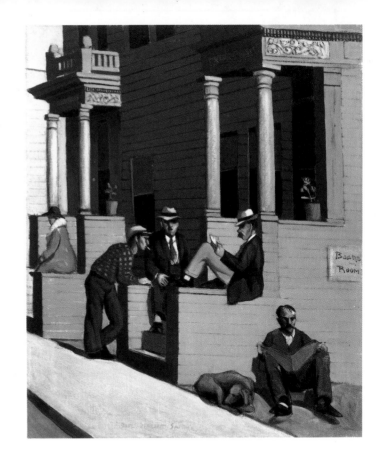

7. *Board and Rooms*, 1931

Oil on canvas, 24¼ × 20 inches
Hood Museum of Art, Dartmouth College
Gift of the Artist

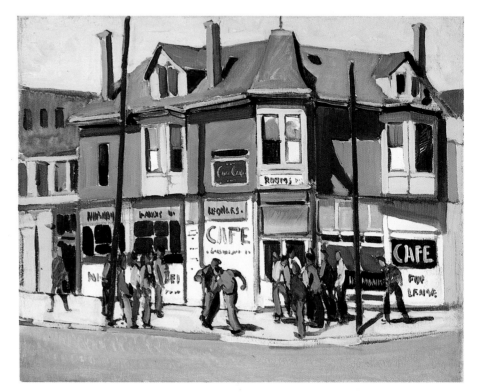

8. *Disagreement*, c. 1931

Oil on canvas, 16¼ × 20¼ inches
Hood Museum of Art, Dartmouth College
Gift of the Artist

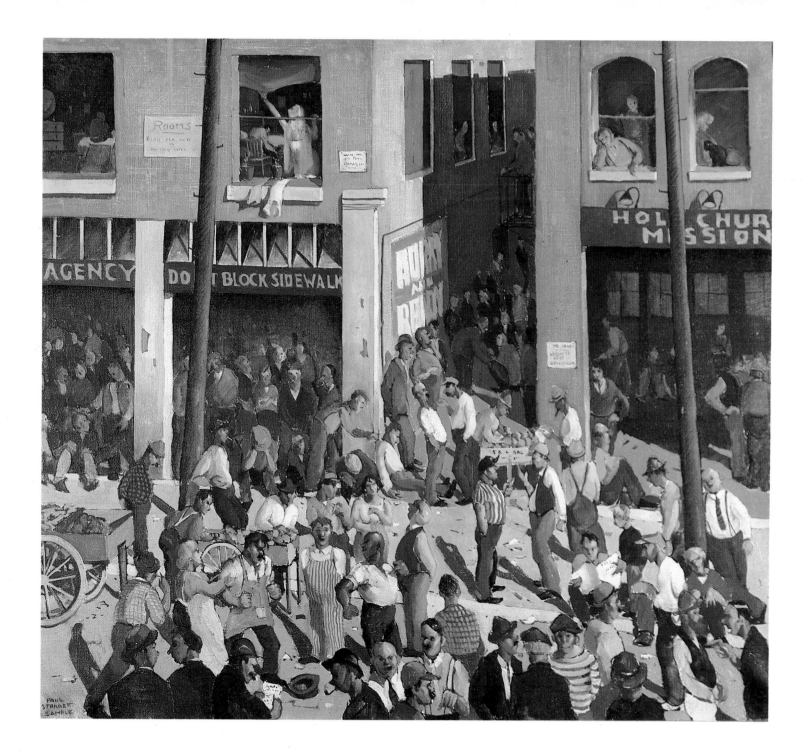

9. *Unemployment*, 1931

Oil on canvas, 36 × 40 inches
National Academy of Design, New York

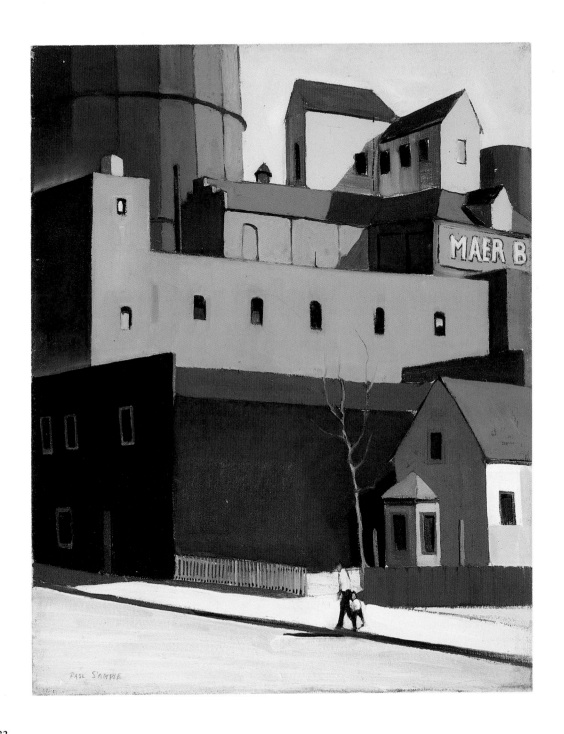

10. *Maer Brewery*, 1932

Oil on canvas, 20⅛ × 16⅛ inches
Hood Museum of Art, Dartmouth College
Gift of the Artist

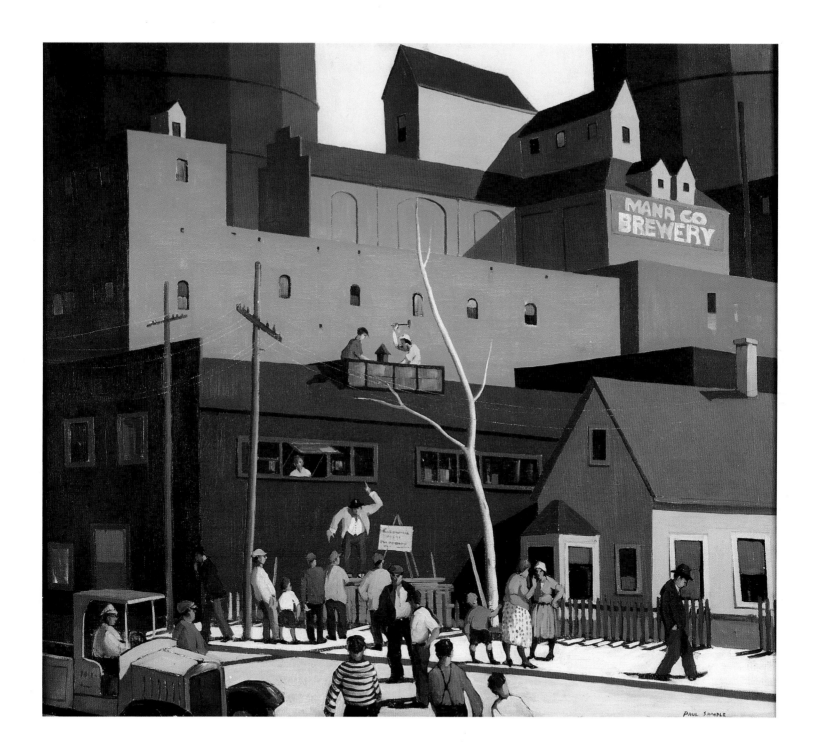

11. *Speech Near Brewery*, 1932

Oil on canvas, 36 × 40 inches
Courtesy of Capricorn Galleries
Bethesda, Maryland

12. *Roque*, 1934

Oil on canvas, 25 × 30 inches
Canajoharie Library and Art Gallery
Canajoharie, New York

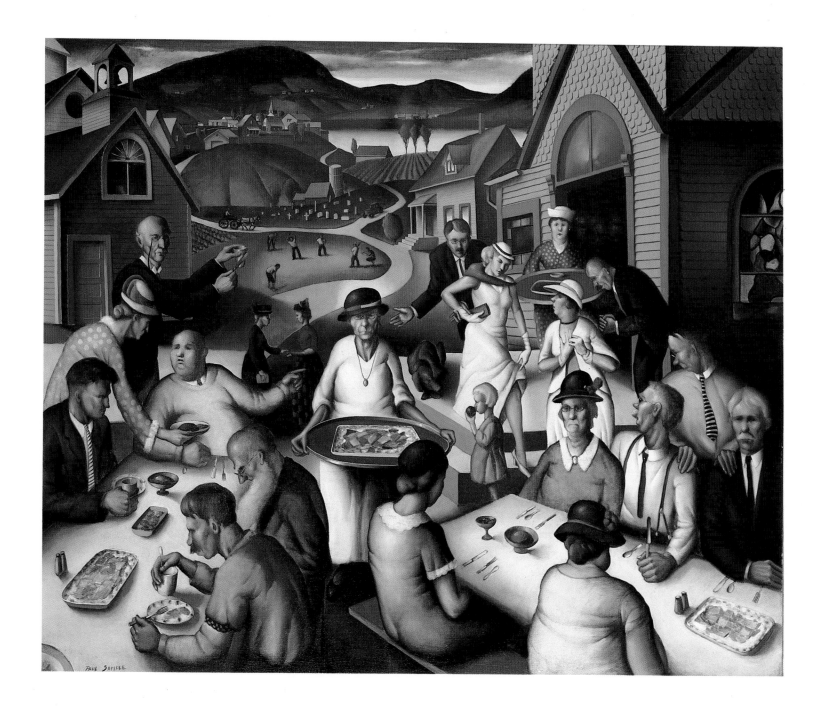

13. *Church Supper,* 1933

Oil on canvas, 40 × 48 inches
Museum of Fine Arts, Springfield, Massachusetts
The James Philip Gray Collection

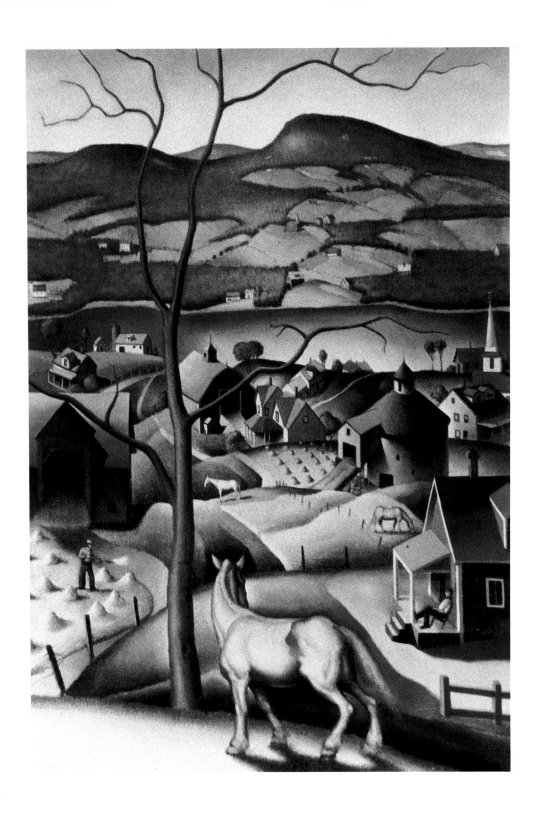

14. *Mountain Village,* 1934

Oil on canvas, 29¾ × 17¾ inches
Collection of the Fisher Gallery
University of Southern California, Los Angeles

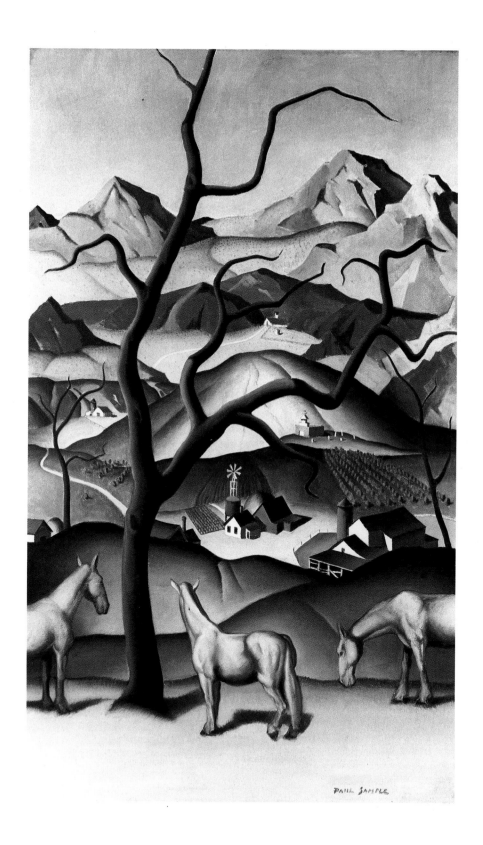

15. *Western Landscape*, c. 1930—38

Oil on canvas, 30⅛ × 18¼ inches
University Art Museum,
University of Minnesota, Minneapolis
Purchase, 36.89

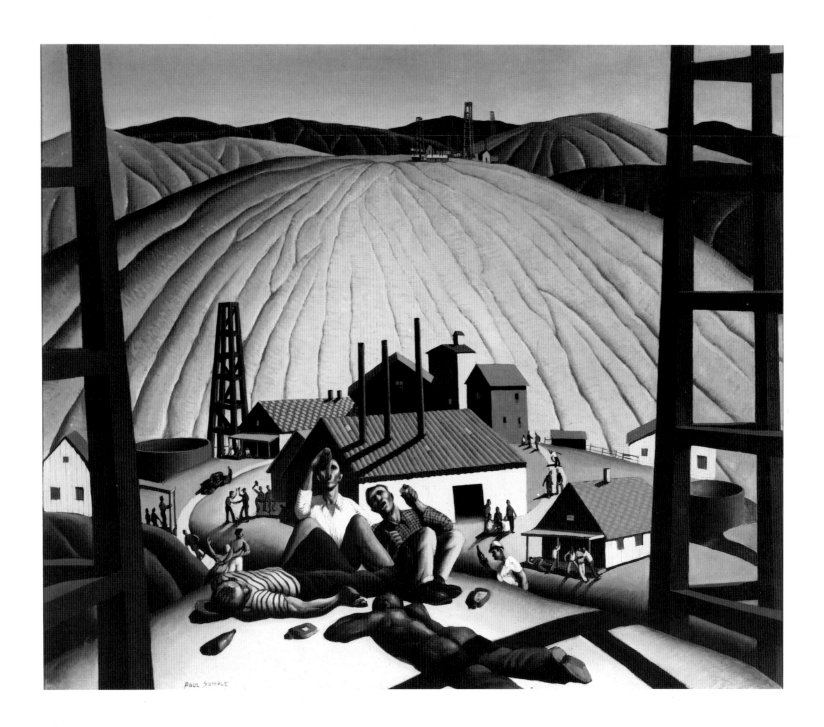

16. *Celebration*, 1933

Oil on canvas, 40 × 48 inches
Paula and Irving Glick

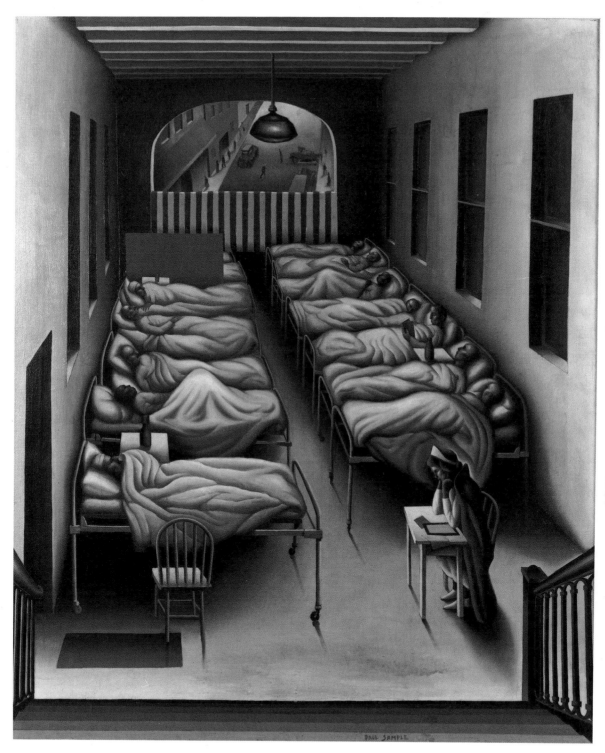

17. *Ward Room,* 1934

Oil on canvas, 36 × 30 inches
Brian David Carmel

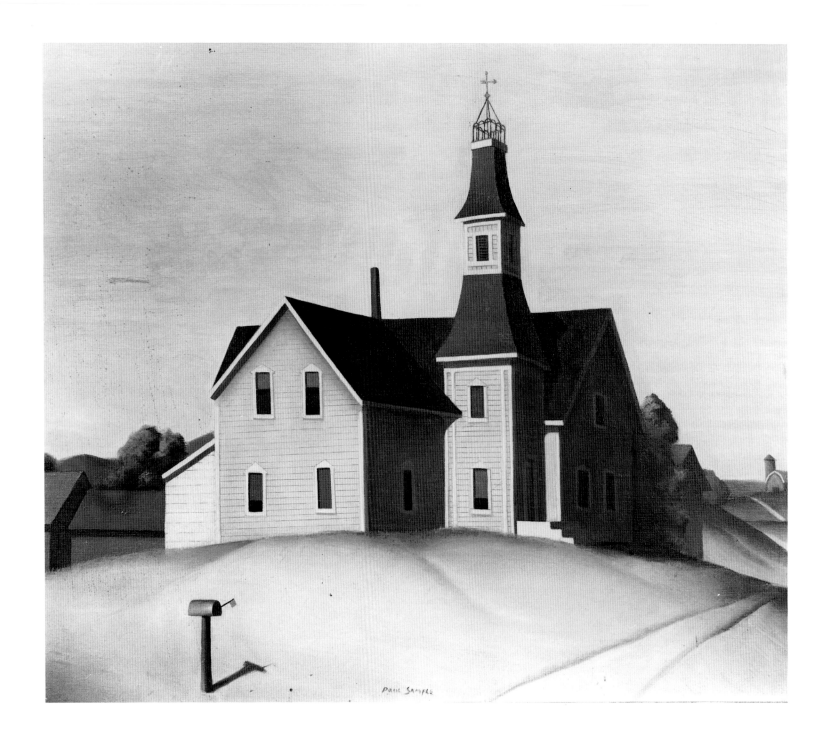

18. *Church in Evansville,* 1934

Oil on canvas, 28 × 24 inches
Susan Poling Norberg
Leesburg, Florida

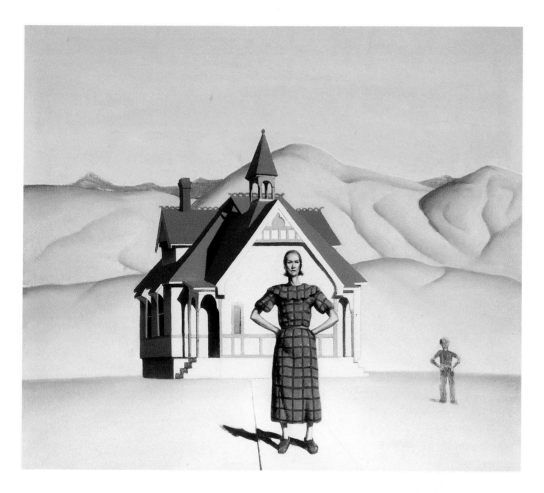

19. *Waiting,* 1935

Oil on canvas, 26 × 30¼ inches
Hood Museum of Art, Dartmouth College
Gift of the Artist

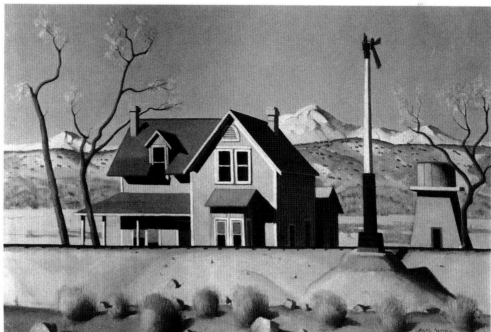

20. *House by the Railroad Tracks,* 1935

Oil on canvas, 19½ × 29½ inches
Clement Caditz

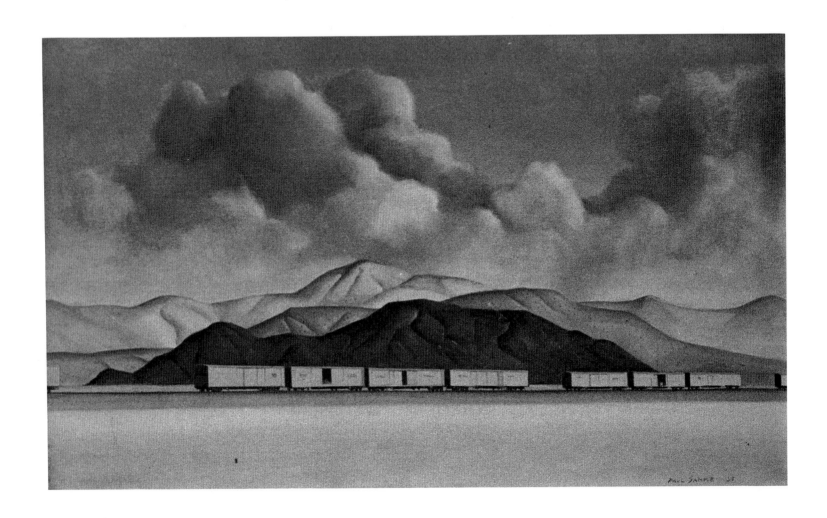

21. *Freight Cars in Desert,* 1935

Oil on canvas, 17¾ × 29¼ inches
Private Collection

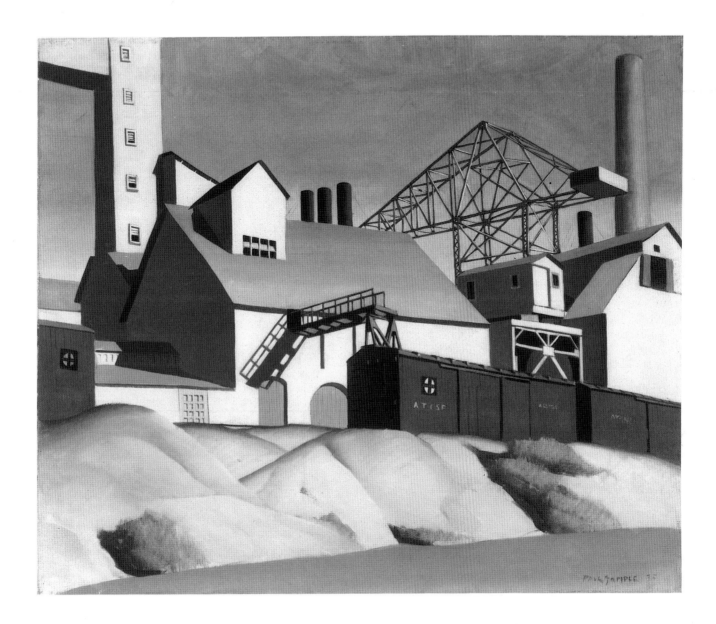

22. *Cement Plant*, 1935

Oil on canvas, 20⅛ × 24 inches
Hood Museum of Art, Dartmouth College
Gift of the Artist

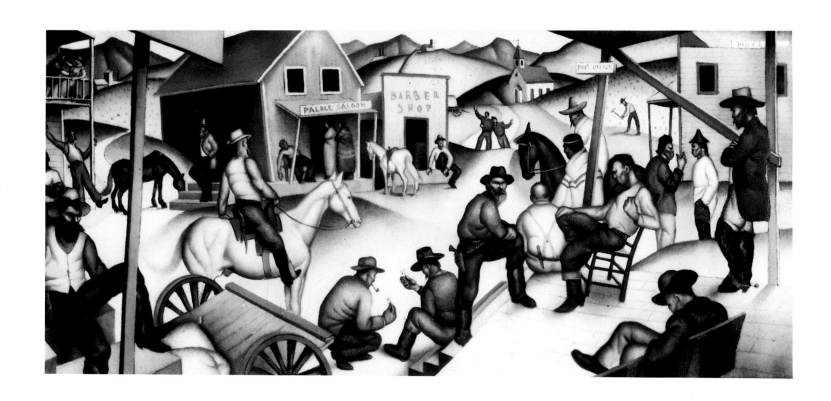

23. *Gold Rush Town*, 1935

Oil on canvas, 12 × 27 inches
Paula and Irving Glick

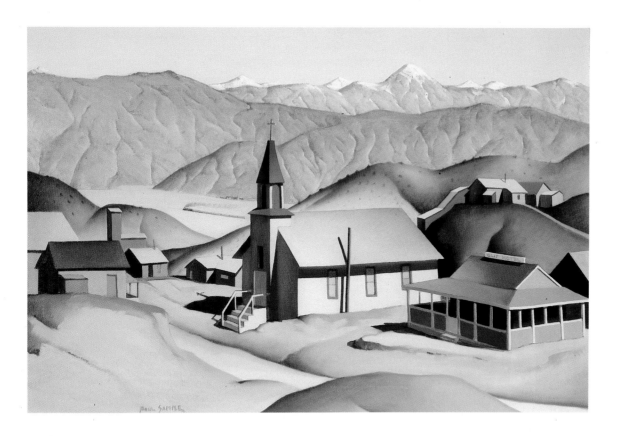

24. *Randsburg,* 1935

Oil on canvas, 20 × 30 inches
Paula and Irving Glick

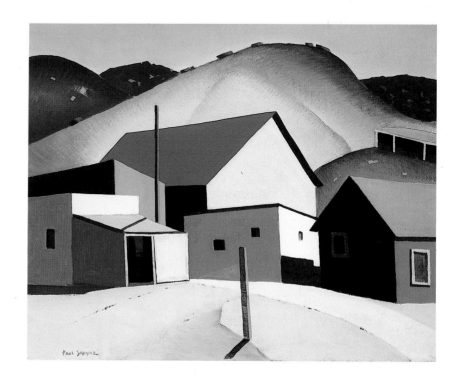

25. *Randsburg Environs,* c. 1935

Oil on canvas, 16⅛ × 20¼ inches
Hood Museum of Art, Dartmouth College
Gift of the Artist

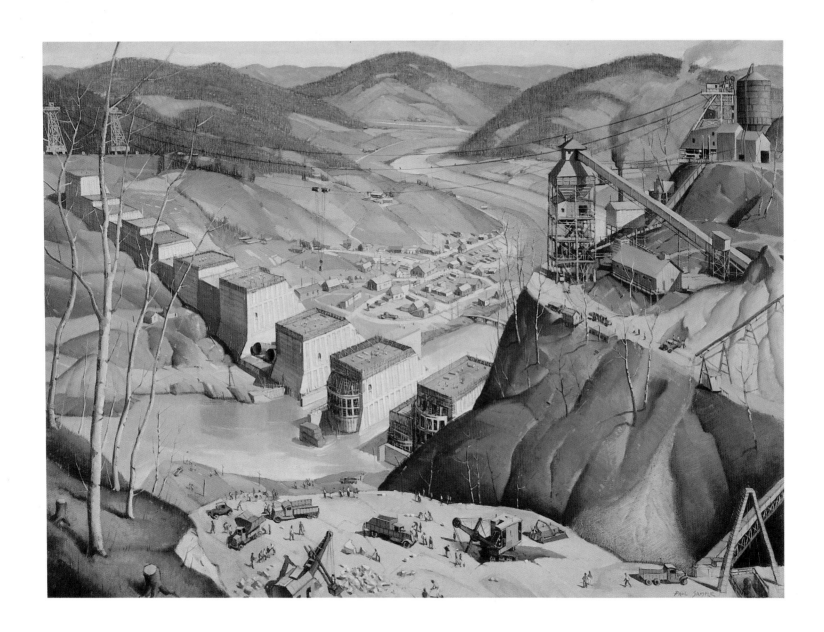

26. *Norris Dam,* 1935

Oil on canvas, 32 × 44 inches
New Britain Museum of American Art
John Butler Talcott Fund 43.9

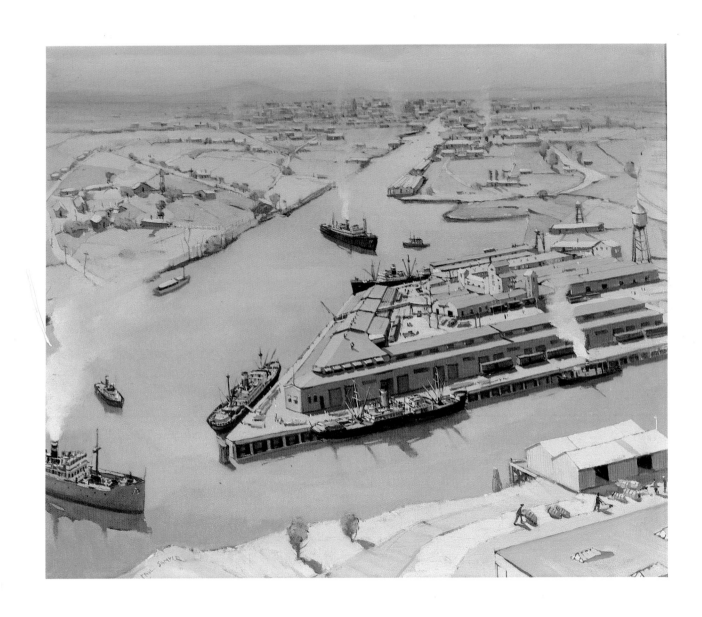

27. *Stockton Harbor,* 1935

Oil on canvas, 25 × 30 inches
D. Wigmore Fine Art, Inc., New York

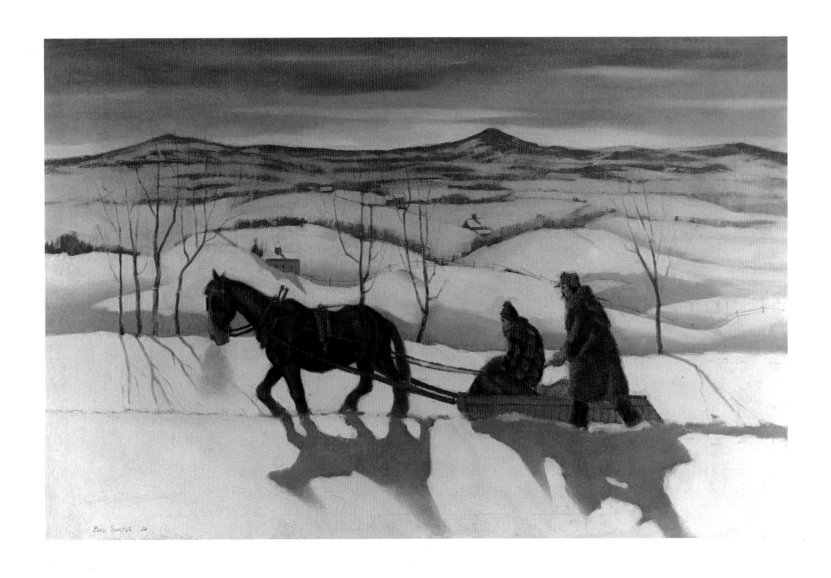

28. *Going to Town,* 1936

Oil on canvas, 26½ × 41 inches
Private Collection

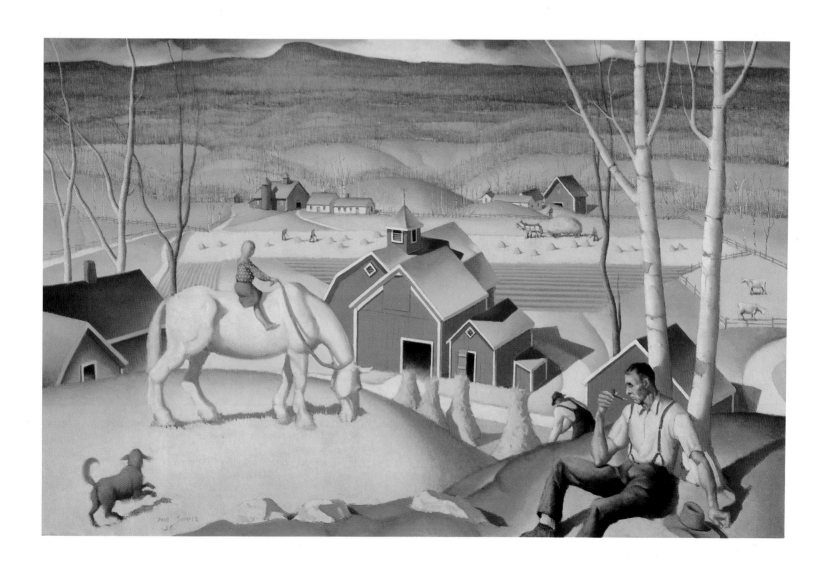

29. *Janitor's Holiday*, 1936

Oil on canvas, 26 × 40 inches
Lent by the Metropolitan Museum of Art
Arthur Hoppock Hearn Fund, 1937

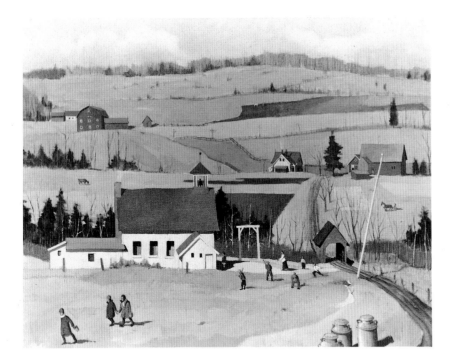

30. *East Charleston School, Vermont,* 1937–38

Oil on canvas, 19½ × 25 inches
Williams College Museum of Art
Williamstown, Massachusetts
Gift of Bartlett Arkell

31. *Sand Lot Ball Game,* 1939

Oil on canvas, 30 × 40 inches
Canajoharie Library and Art Gallery
Canajoharie, New York

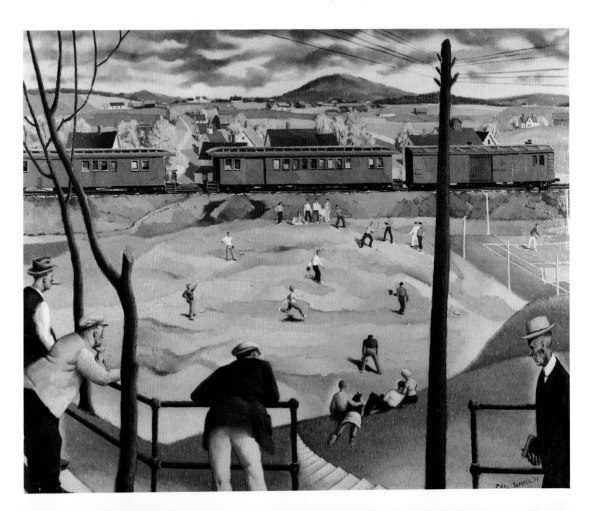

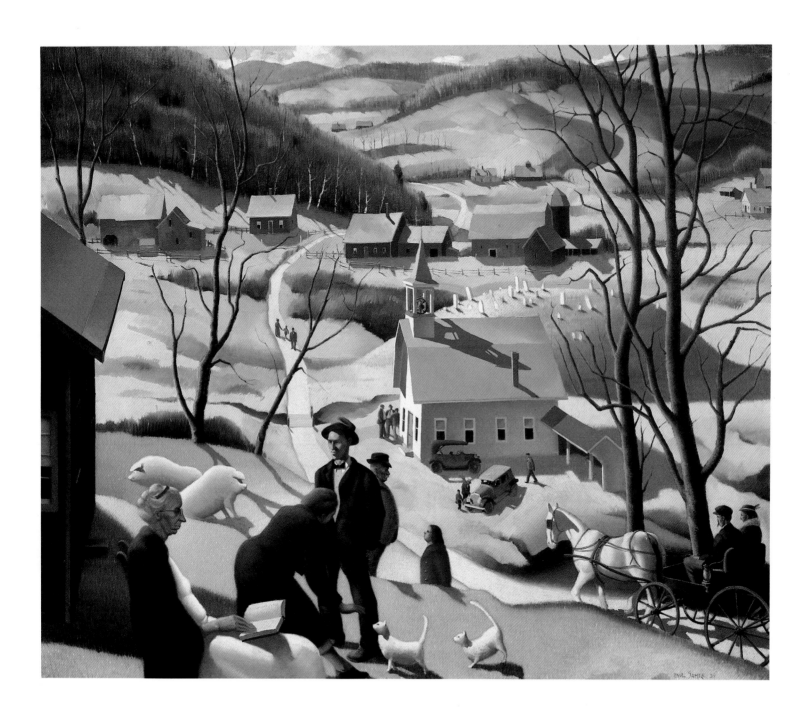

32. *Beaver Meadow,* 1939

Oil on canvas, 40 × 48¼ inches
Hood Museum of Art, Dartmouth College
Gift of the Artist

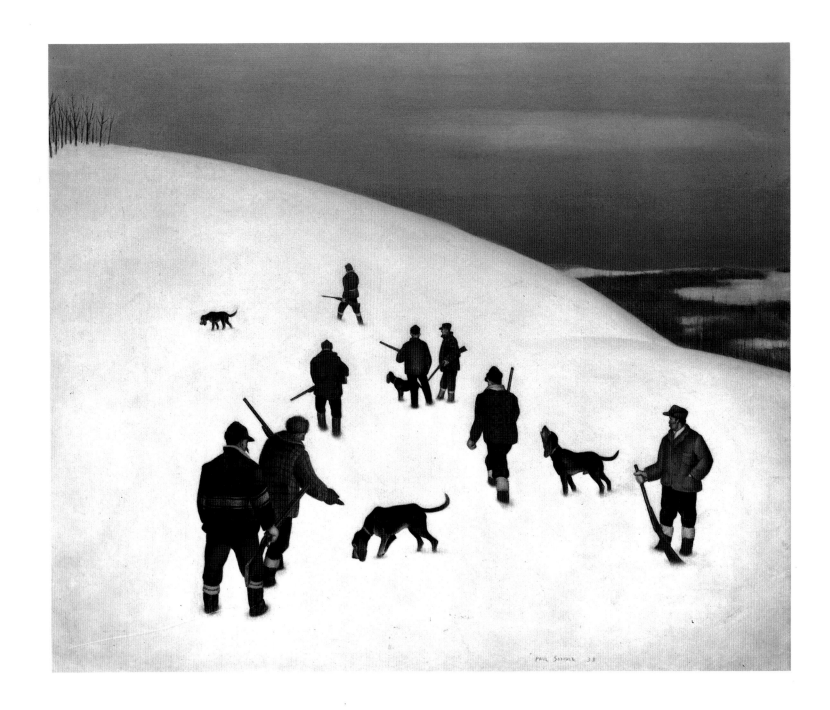

33. *Lamentations V : 18 (Fox Hunt)*, 1938

Oil on canvas, 30 × 36 inches
Addison Gallery of American Art
Phillips Academy, Andover, Massachusetts
Gift of Milton Lowenthal

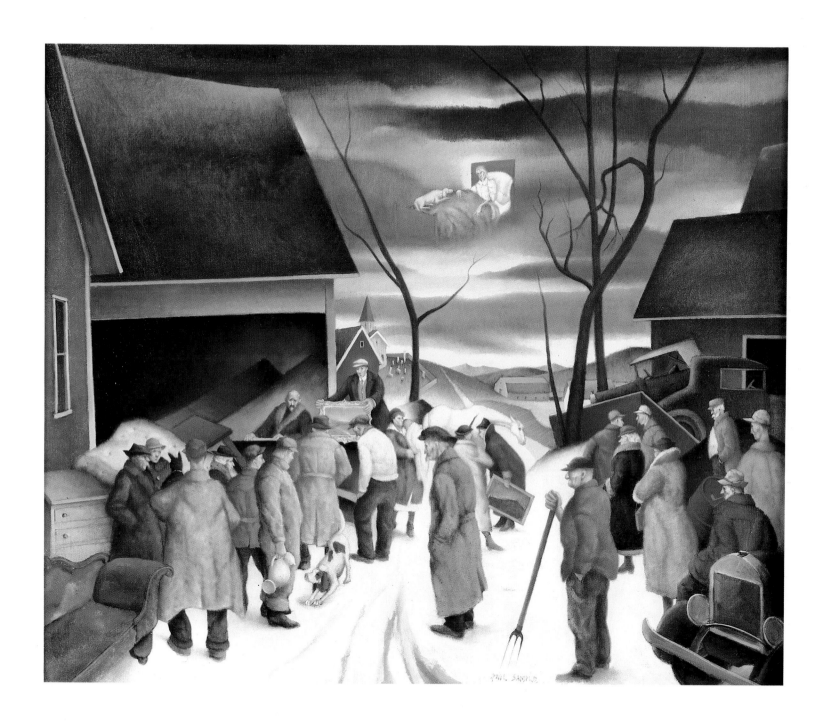

34. *Matthew VI : 19 (The Auction)*, 1939

Oil on canvas, 30 × 36 inches
Lowe Art Museum, University of Miami
Gift of Mr. and Mrs. Myron Hokin

35. *Nathaniel L. Goodrich,* c. 1941

Oil on canvas, 30 × 36 inches
Hood Museum of Art, Dartmouth College
Gift of the Artist

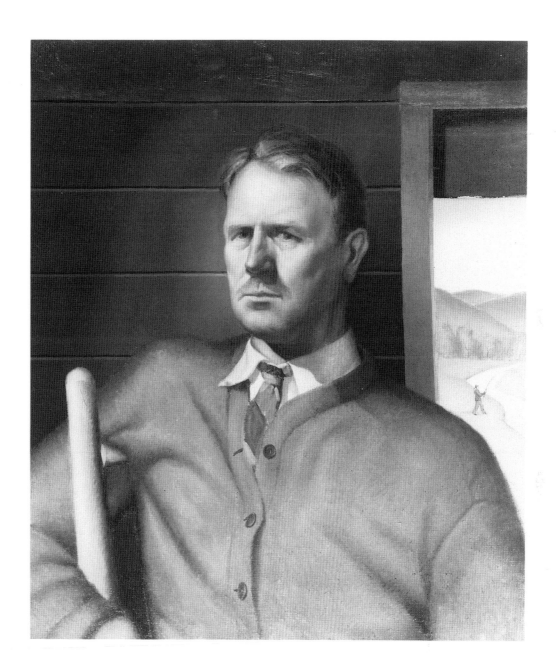

36. *Self Portrait*, 1937

Oil on canvas, 24 × 20 inches
National Academy of Design, New York

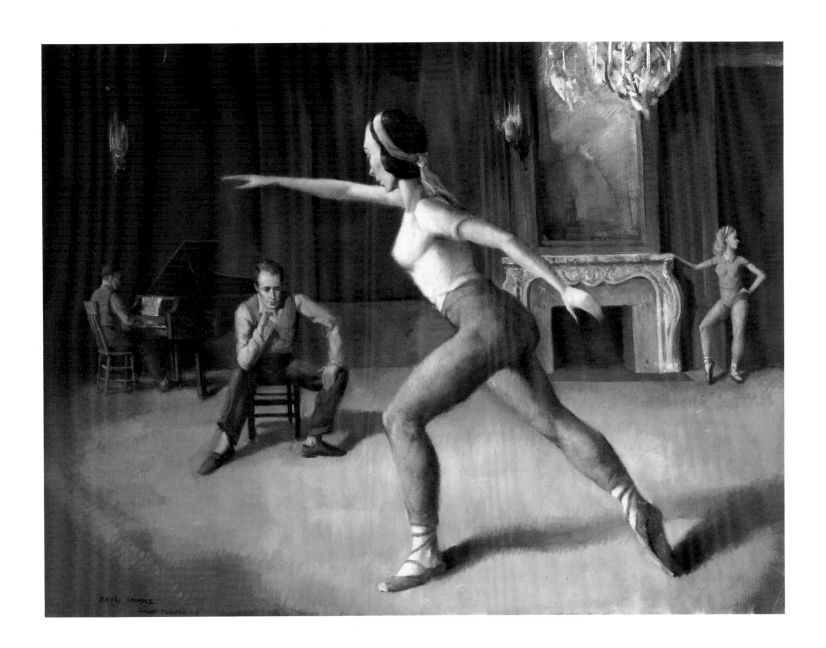

37. *Rehearsal (Nora Kaye Rehearsing)*, 1941

Oil on canvas, 30⅛ × 40¼ inches
Private Collection

Sketch for *Will Bond,* 1940

Pencil on paper, 12 × 18 inches
Hood Museum of Art, Dartmouth College
Gift of the Artist

38. *Will Bond,* 1940

Oil on canvas, 30 × 25⅛ inches
Hood Museum of Art, Dartmouth College
Gift of the Artist

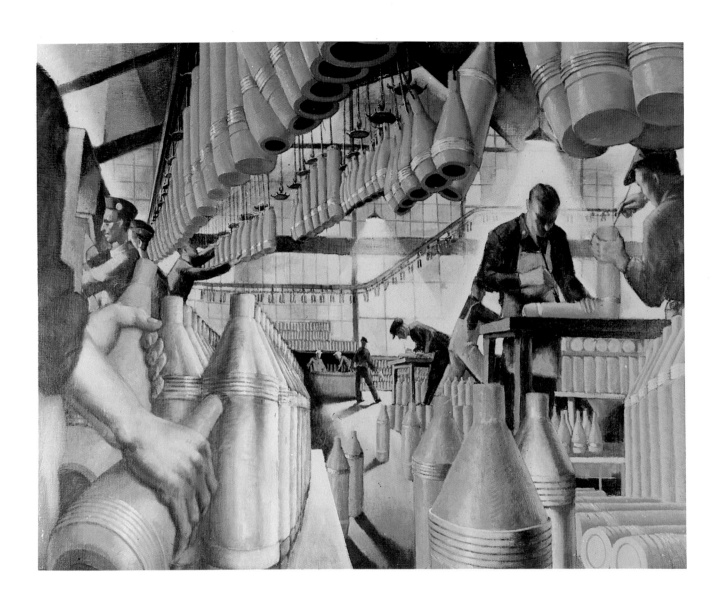

39. *Shell Factory*, 1941

Oil on canvas, 25¼ × 32 inches
U.S. Army Center of Military History

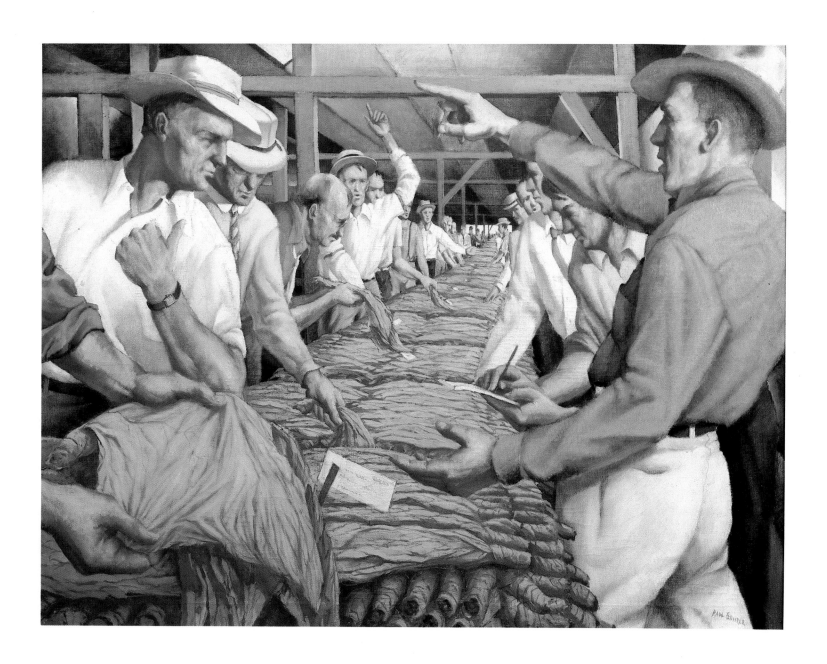

40. *Tobacco Auction,* 1941

Oil on canvas, 31 × 40 inches
Private Collection

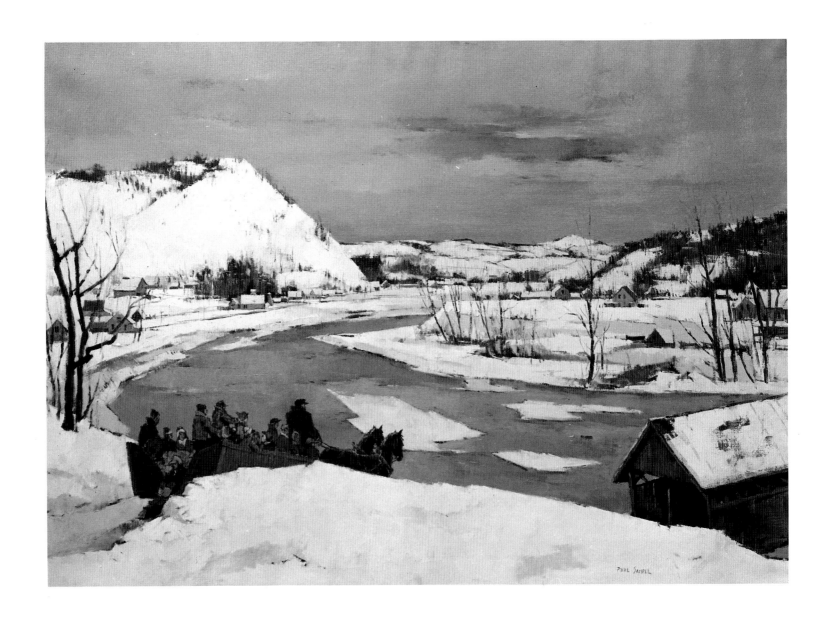

41. *Sharon's Sleigh Ride*, 1941

Oil on canvas, 34 × 38 inches
The Currier Gallery of Art
Manchester, New Hampshire

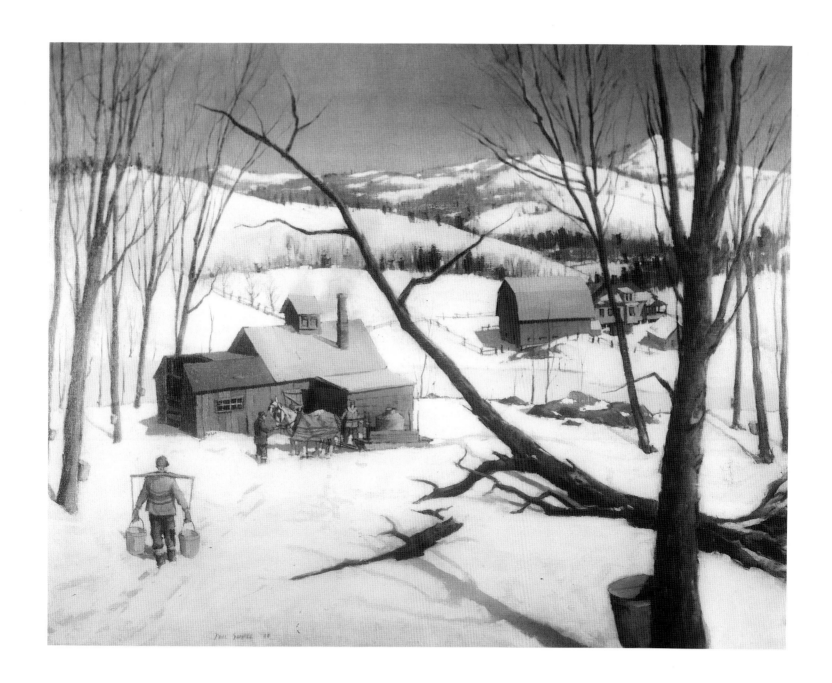

42. *Maple Sugaring*, 1944

Oil on canvas, 29½ × 37½ inches
Mr. and Mrs. Joseph S. Caldwell, III
Dartmouth College Class of 1951

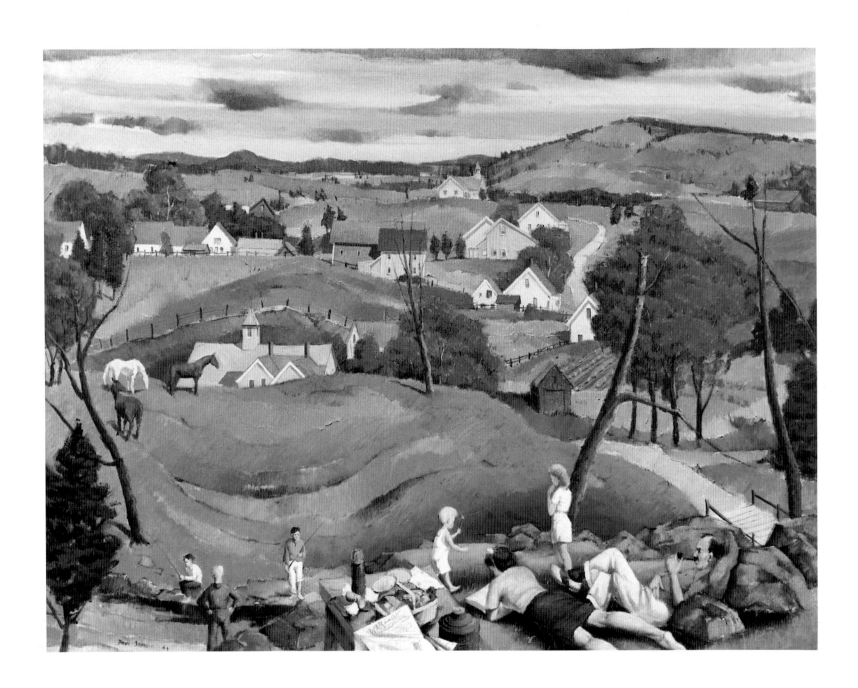

43. *Two Weeks with Pay*, 1944

Oil on canvas, 36½ × 48½ inches
Abbott Laboratories Collection

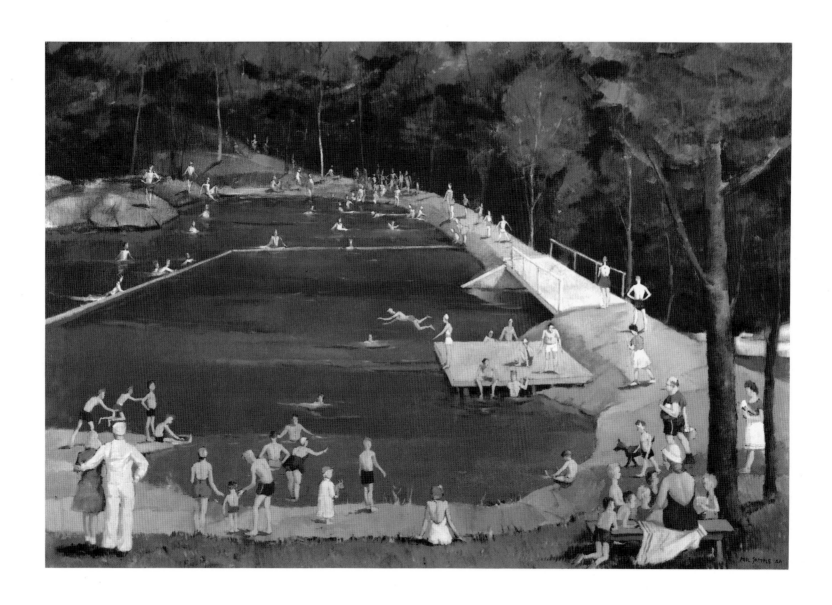

44. *Norwich Holiday (The Swimming Pool)*, 1944

Oil on canvas, 33 × 48 inches
Town of Norwich, Vermont

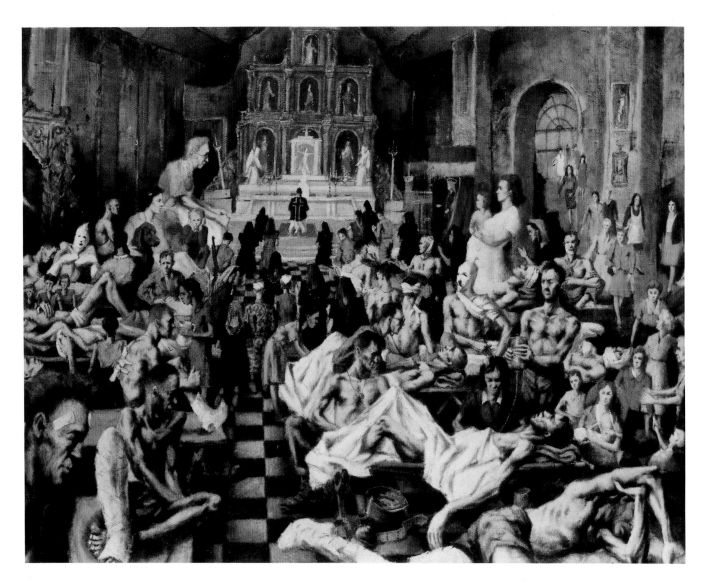

45. *Field Hospital in a Church*
(*Delirium Is Our Best Deceiver*), 1944

Oil on canvas, 34 × 48½ inches
U.S. Army Center of Military History

Sketch for *Field Hospital in a Church*
(*Delirium Is Our Best Deceiver*), 1944

Pencil on paper, 12 × 18 inches
Hood Museum of Art, Dartmouth College
Gift of the Artist

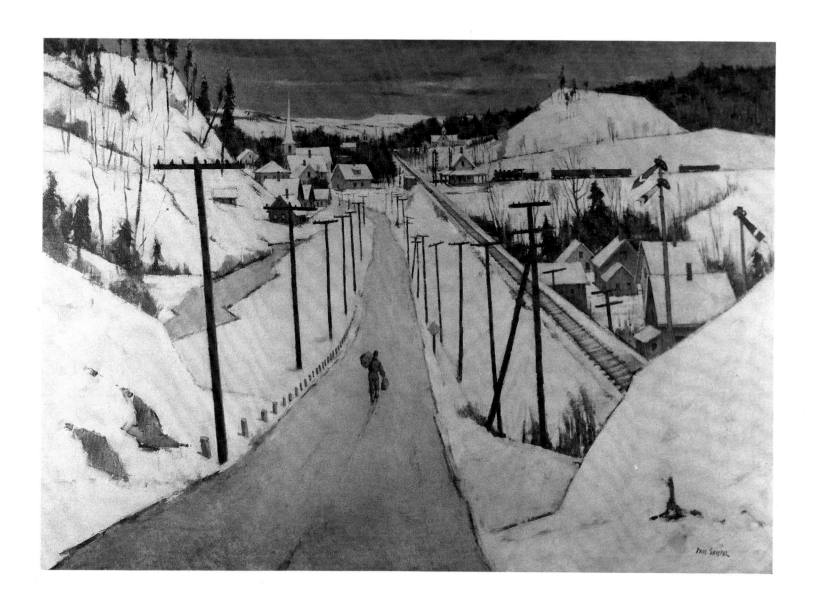

46. *The Return*, 1946

Oil on canvas, 36 × 50 inches
Mr. and Mrs. Robert Goshorn

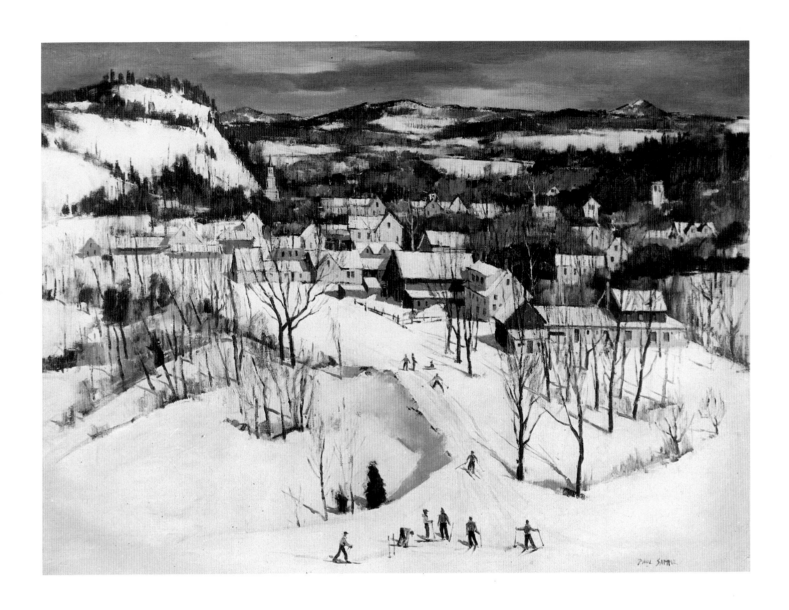

47. *Winter Holiday*, 1948

Oil on canvas, 30 × 40 inches
Springville Museum of Art
Springville, Utah

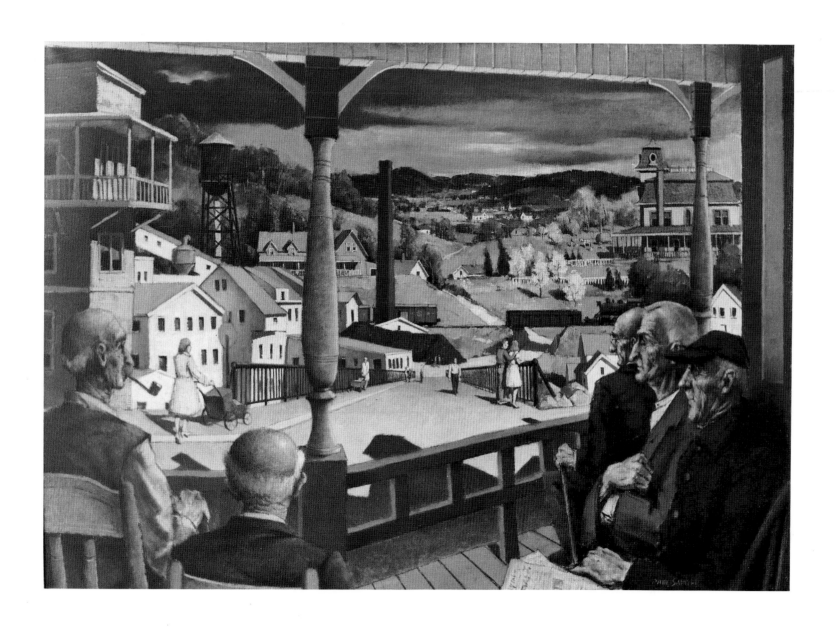

48. *Remember Now the Days of Thy Youth,* 1950

Oil on canvas, 34 × 48 inches
Hood Museum of Art, Dartmouth College
Gift of Frank L. Harrington, Class of 1924

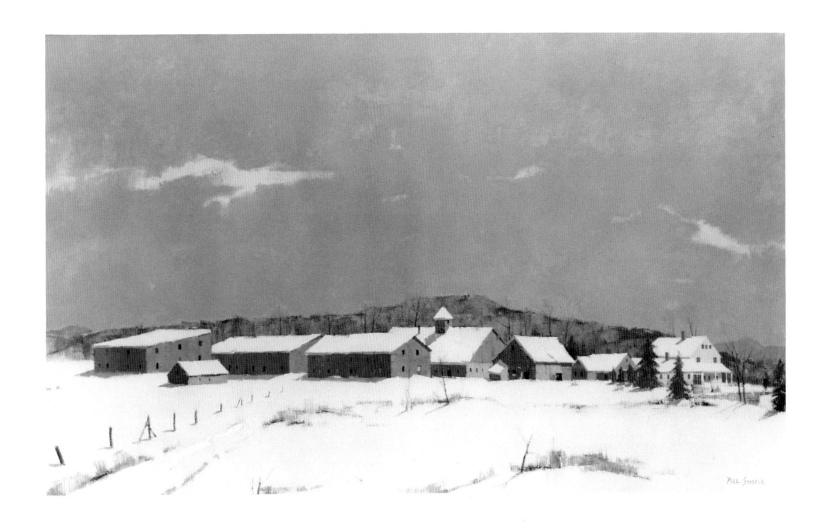

49. *Hackleboro Farm,* 1968

Oil on canvas, 28 × 48 inches
Mr. and Mrs. Robert P. Burroughs

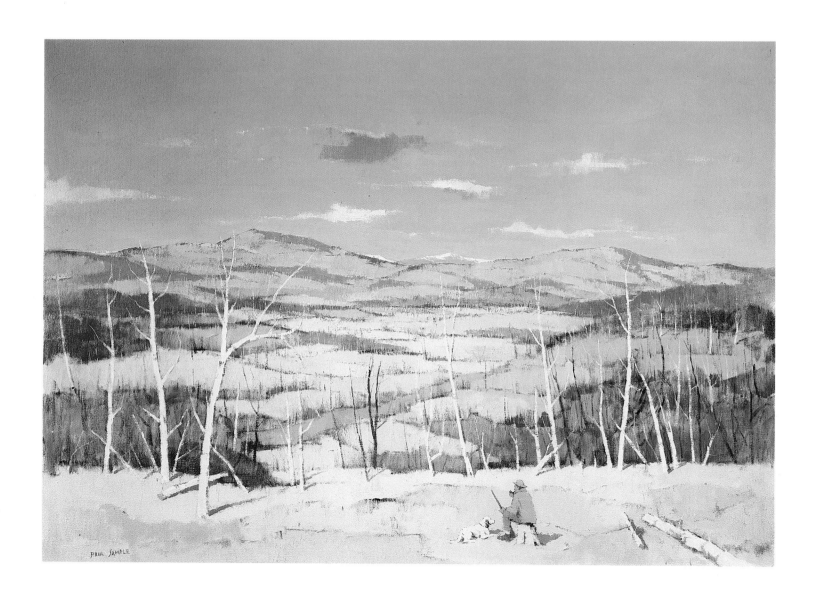

50. *Hunter in Landscape,* 1966

Oil on canvas, 38 × 54 inches
Hood Museum of Art, Dartmouth College
Gift of the Class of 1926,
in memory of Sidney C. Hayward, Class of 1926

Works on Paper

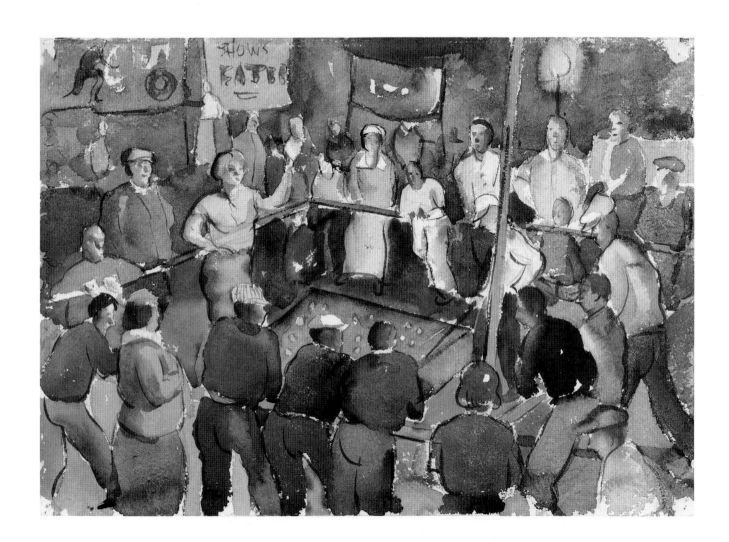

51. *Carnival Game*

Watercolor over pencil indications,
11⅜ × 16¼ inches
Hood Museum of Art, Dartmouth College
Gift of the Artist

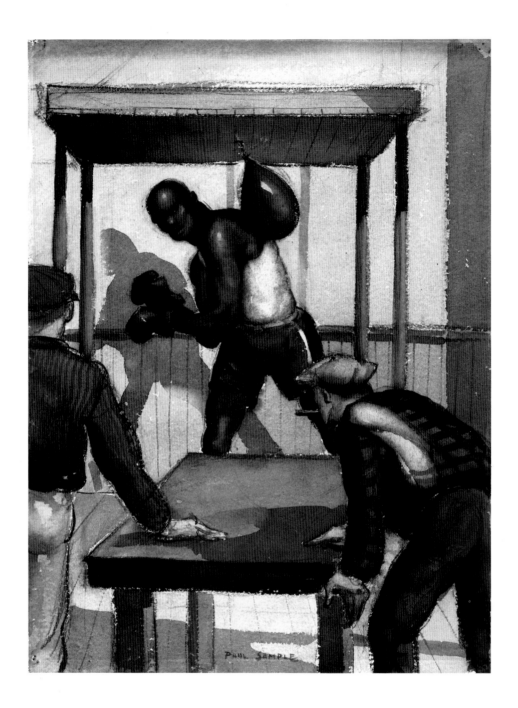

52. *Punching the Bag*, 1935

Watercolor over pencil indications,
15¼ × 11⅜ inches
Hood Museum of Art, Dartmouth College
Gift of the Artist

53. *Plaster Plant, Houston, Texas,* c. 1936–37

Watercolor, II × 12½ inches
A friend of Dartmouth

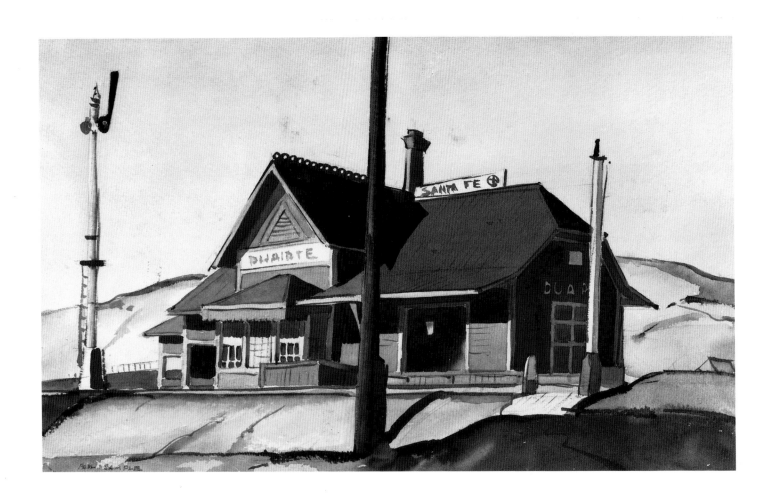

54. *Santa Fe Station,* 1935

Watercolor over pencil indications,
12¼ × 19½ inches
Hood Museum of Art, Dartmouth College
Gift of the Artist

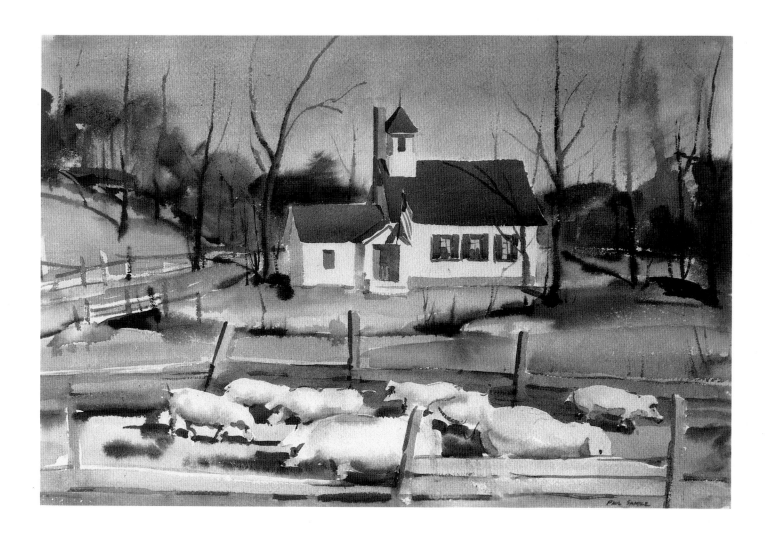

55. *Real Wealth,* 1940

Watercolor, 15 × 22 inches
Museum of Fine Arts, Boston

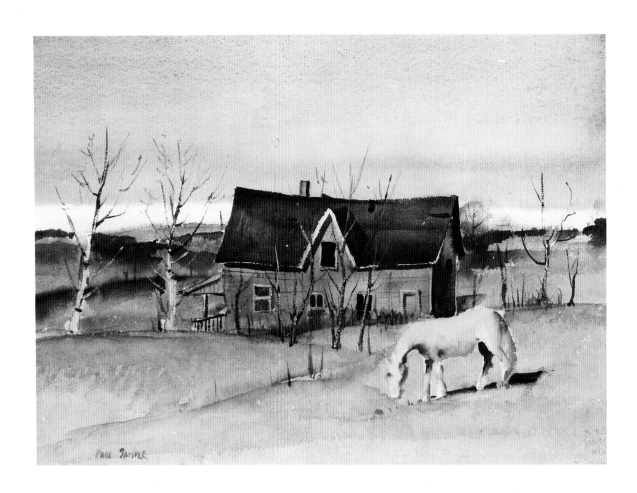

56. *Deserted House*

Watercolor, 11⅛ × 15¼ inches
The Brooklyn Museum
Gift of Friends of Southern Vermont Artists, Inc. 40.380

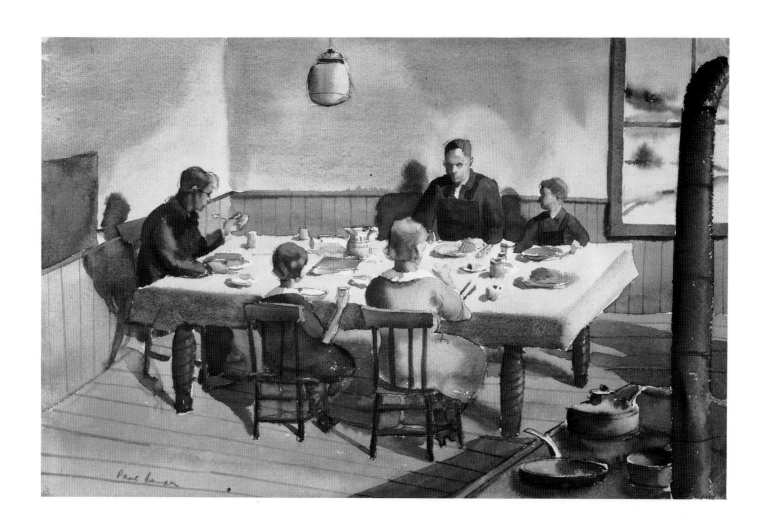

57. *Hoisington Family Dinner*

Watercolor over pencil indications,
12¾ × 19½ inches
Hood Museum of Art, Dartmouth College
Gift of the Artist

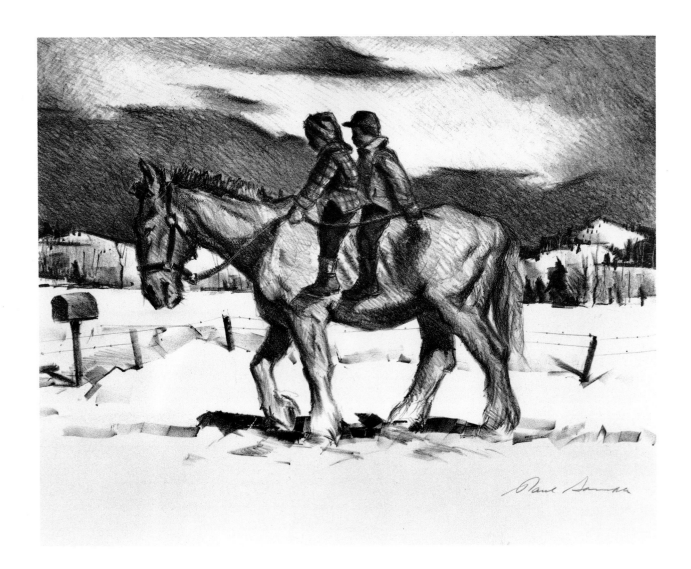

58. *Rural Delivery*

Lithograph, 11⅞ × 16 inches
Hood Museum of Art, Dartmouth College
Purchased through the Julia L. Whittier Fund

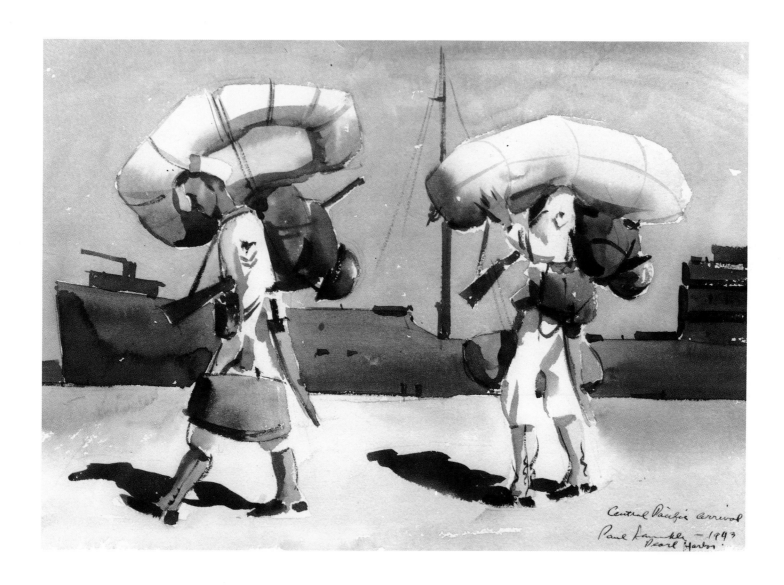

59. *Central Pacific Arrival,* 1943

Watercolor, 14 × 18¼ inches
D. Wigmore Fine Art, Inc., New York

60. *Untitled, Seated Male from Back*

Watercolor, 18 × 12 inches
Hood Museum of Art, Dartmouth College
Gift of the Artist

61. *Seated Nude from Back*

Watercolor, 17¾ × 11¾ inches
Hood Museum of Art, Dartmouth College
Gift of the Artist

62. *The Junction,* c. 1935

Watercolor, 14⅞ × 22⅛ inches
Joslyn Art Museum, Omaha, Nebraska

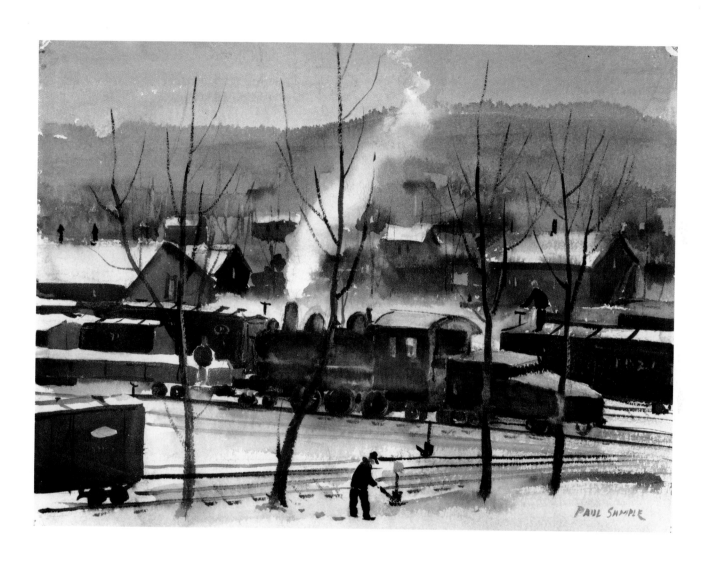

63. *Switching Cars*

Watercolor, 11⅜ × 15¼ inches
Hood Museum of Art, Dartmouth College
Gift of the Artist

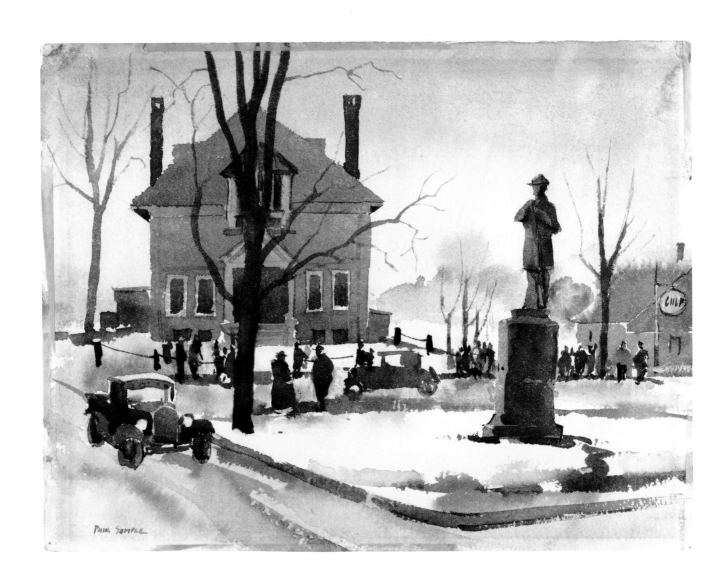

64. *Town Meeting*

Watercolor, 11⅝ × 15⅛ inches
Hood Museum of Art, Dartmouth College
Bequest of Harold G. Rugg, Class of 1906

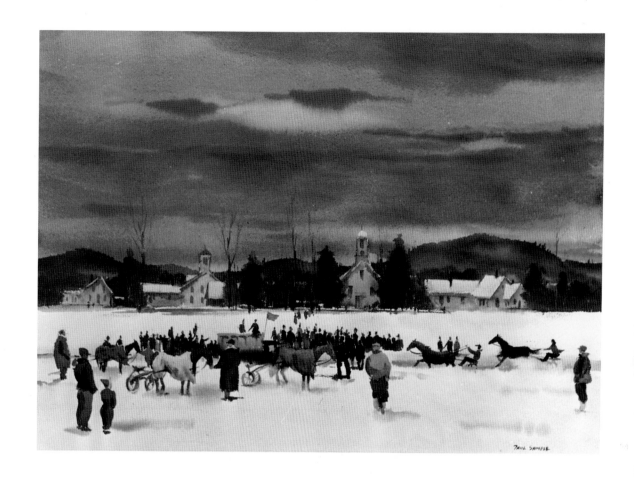

65. *Winter Racing in Canaan*

Watercolor, 18¾ × 26½ inches
William A. Farnsworth Library and Art Museum
Rockland, Maine

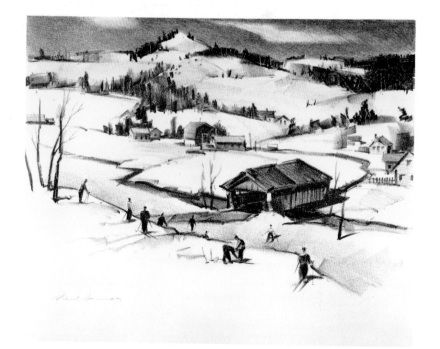

66. *The Slope Near the Bridge*

Lithograph, 11⅞ × 16 inches
Hood Museum of Art, Dartmouth College
Purchased through the Julia L. Whittier Fund

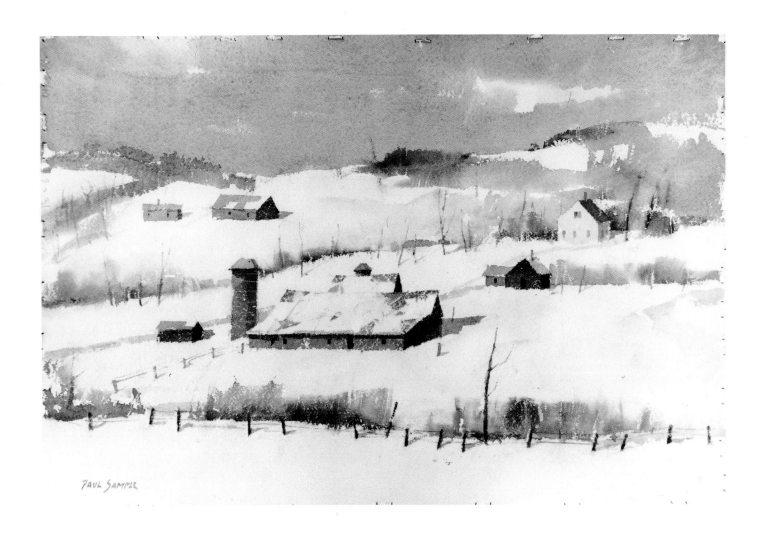

67. *Landscape,* 1974

Watercolor, 15½ × 22¾ inches
Private Collection

Photo Credits